THE ART OF ROCK

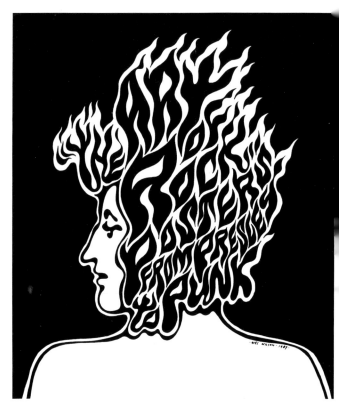

THE ART OF ROCK

POSTERS FROM PRESLEY TO PUNK

Paul D. Grushkin
Artworks photographed by Jon Sievert

Abbeville Press Publishers
New York • London

To the memory of Rick Griffin, Charles F. Tilghman, Sr., and Bill Graham.

Editor: Alan Axelrod
Designers: Philip Grushkin, Ronald R. Misiur
Production Editors: Amy Handy, Abigail Asher
Production Supervisor: Simone René

Jacket front artwork by Wes Wilson; posters on jacket back by Art Chantry (*Tina Turner*), Rick Griffin (*Grateful Dead*), John Van Hamersveld (*Jimi Hendrix*) and Su. Suttle (*Talking Heads*).

The Art of Rock was produced with the cooperation of the Bay Area Music Archives, San Francisco.

First hardcover Tiny Folio™ edition

15 14 13 12 11 10 9 8 7 6 5

ISBN 978-0-7892-0611-4

Library of Congress Catalog Card Number: 93-72346

Additional copyright information:
The works reproduced on pp. 64–72 are the registered copyrights of Family Dog Productions. Family Dog Productions is the d.b.a. of Chester L. Helms, 771 Bush Street, San Francisco, CA 94108.
The posters on pp. 74–77 are copyright © Wes Wilson.
The posters on pp. 46, 214, 275, and 279 are the registered copyrights of Gunther Kieser, and the exclusive licensee of the works is Artrock, 893 Folsom Street, San Francisco, CA 94107.

For bulk and premium sales and for text adoption procedures, write to Customer Service Manager, Abbeville Press, 116 West 23rd Street, New York, NY 10011, or call 1-800-ARTBOOK.

Visit Abbeville Press online at www.abbeville.com.

CONTENTS

ACKNOWLEDGMENTS

Very special thanks to:
Paul Getchell, Kevin Plamondon, Frank Vacanti, Phil Cushway, J. Kastor
Troy Alders, David Getz, Jim Sherraden, John van Hamersveld, Chris
Coyle, Cummings Walker, Andy Levison, James Stark, Walter Medeiros,
Dennis Nolan, Bob Fratti, Mitch Diamond, Jerry Pompili, Joel Selvin, John
Goddard, Richard Stutting, Debi Jacobson, Alton Kelley, Ed Walker, Jack
Wolffers, Bob Beerbohm, Stanley Mouse, Ray Anderson, Ron Schaeffer,
Wes Wilson, Rob Frith, John Kuzich, Eric King, Victor Moscoso,
Don Bratman, David Faggioli, Hal Feiger, Rusty Goldman, Art Chantry,
Randy Tuten, Chet Helms, Dennis King, David Singer, Su. Suttle, Peter
Belsito, Tim Patterson, Jeff Berger, Shawn Kerri, Gary Grimshaw, Levon
Mosgofian, Ben Friedman, editor Alan Axelrod and everyone at Abbeville
Press (Bob Abrams, Myrna Smoot, Susan Costello, Laura Straus, Dorothy
Gutterman, Dana Cole, Rozelle Shaw), and Wendy and Jon Sievert, Phil
and Jean Grushkin, and Jane Eskilson, Jessica, and Jordan, and all the
artists and collectors.

INTRODUCTION

A plague of crazed critics, curators, and graduate students will descend upon me if I declare that rock posters are great modern art. So what I'll tell you is that they inspire extraordinary love and passion and that, unlike most other modern artworks, they are truly popular: thousands of people all around the world now avidly collect them.

Many of the posters are exceptional graphic achievements: their printing employs the highest skills, and the poster artists themselves have extended the limits of their medium. These artists and printers were innovators bent on bringing forth something manifestly new and exciting.

Rock posters have been around as long as rock music has—about thirty-five years. Not since Europe of the 1930s has poster art played so significant a role in promoting popular entertainment. Moreover, rock posters have become a leading popular art form that has greatly influenced such related graphic fields as advertising. Rock art is tied directly to the changing music of a thirty-five-year period; simply put, because there are rock concerts, there are inevitably rock posters. It is also true that rock music has reflected, even as it has helped to shape, its thirty-five-year span of American and international culture. And so the posters are a visual history not only of the music but also of a little bit of the world that produced the music.

Rock has many roots and branches, and what this book calls rock poster art also embraces other forms of popular music related to rock. Black music had an obvious and great effect, as did country. The posters help to tell how and why this is so. The book begins in the mid-1950s, when rock was very young and when for the most part black people were still setting the popular music trends followed by various white performers. By 1955, swing-jazz jump bands, and early rhythm and blues had yielded to the likes of James Brown and, a little later, Elvis Presley. With the sixties came the Temptations and Aretha Franklin, then Bob Dylan, and the storming of America by "British Invasion" groups like the Beatles, the Rolling Stones, the Animals, Gerry and the Pacemakers, Herman's Hermits, and so on.

All the posters of rock's early period—1955 to 1965—whether advertising white or black acts, were done in a "boxing style," with heavy emphasis on key words—usually names—done in woodblock. Though plain pieces, these posters are nevertheless tremendously evocative. They have a luminous quality, a rich patina of age. They are not intentionally beautiful, but they capture rock's first, vanished era perfectly and bring back memories of music that was raw and authentic. Here, they say, is where it all began.

Next came the psychedelic era of the mid- and late 1960s, extending into the very early 1970s. This was the Golden Age of the rock poster and one of the great flowerings of poster art in general. Partly the result of America's response to the British

Invasion, it began in San Francisco and Los Angeles, with such groups as the Charlatans, Country Joe and the Fish, the Byrds, the Doors, and the Grateful Dead. Then it came in a great rush from all other areas of the country. The new music led to a new school of rock poster art, produced in great quantity and received with tremendous enthusiasm. Vivid and imaginative, it stands in dramatic contrast to the art of rock's earlier period.

After the early 1970s, psychedelic music and art—associated with counterculture communities and hippie communes—began to yield to a mainstream increasingly dominated by music industry businessmen. By the mid-1970s, promoting rock was often a corporate rather than a communal endeavor, and the mass-media appeals of newspaper and magazine ads replaced much poster art. What posters did exist displayed a professional maturity and were often effective translations of music into graphic terms. But, like the music itself, the rock poster, now more or less a corporate entity, had lost much of its appealing naiveté.

Beginning in the late 1970s and continuing in varying degrees into the present, a revolution has been under way, a move against the mainstream. Punks and new wavers became rock's cutting edge, and their aggressive sound has been accompanied by a return to street-scorching lamppost art. Unlike psychedelic art, punk and new wave posters aren't meant to promote inward exploration. Nor are they intended to be displayed on the bedroom or living room wall. They more closely resemble the early rhythm and blues bills and, like them, are meant to be seen

outside, on the street. In some purely unconscious way, rock art has thus come full circle.

In the early days of the psychedelic scene, poster art was available to even the most casual rock fan. It was for sale in many stores, like the Print Mint, the Psychedelic Shop, or Ben Friedman's Postermat, all in San Francisco. It was also being given away by rock promoters like Bill Graham and by the Family Dog collective, both of whom even sent a poster man around to distribute the posters to head shops, the Berkeley campus, and other likely places. Graham's posters for his shows at the Fillmore Auditorium and the Family Dog's posters for theirs at the Avalon Ballroom are especially prized today.

After a time, Bill Graham and the Family Dog promoters could no longer afford to give away the large posters and instead sold them wholesale to stores, where the usual retail price, up through 1970 or so, was one dollar each.

The price of rock art has appreciated considerably since the 1960s. Original art—drawings, paintings, artists' mechanicals (lay-outs from which posters are made)—now commands a hefty price, and quite a number of rare posters could cost a collector upward of five hundred dollars—even more, if the sale takes place on the East Coast. Fundamentally, however, rock art isn't "high art"—it isn't so exalted that it's out of the reach of even the novice collector.

1.
ROOTS

I remember the first time I met the great bluesman, Howlin' Wolf, in 1966. He started talking about white blues singers, a new concept at the time. He liked Paul Butterfield, he said, also "that other boy—what's his name? Somewhere out in California, that 'Hound Dog' number." He was talking about Elvis Presley. But surely Elvis couldn't be considered strictly a blues singer, somebody pointed out. Maybe not, conceded Wolf in that great hoarse growl of his, but "he started from the blues. If he stopped, he stopped. It's nothing to laugh at. He made his pull from the blues."

> PETER GURALNICK
> album liner notes (February 1985)
> for Elvis Presley, *Reconsider Baby*
> (RCA AFL1-5418)

Everything "makes its pull" from something. The earliest concert posters that promoted rock were hardly revolutionary; they owe much to advertising art associated with carnivals, circuses, vaudeville, minstrel shows, Grand Ole Opry–style

country music, and even big-band jazz.

Much of the poster art of the mid-1950s and early 1960s was developed in the print shops that had produced the earlier street advertisements. For printers accustomed to developing standard window cards and telephone pole posters to satisfy the needs of performers' managers, booking agents, and early show promoters during the twenties, thirties, and forties, it was an easy transition to the new promotions associated with rhythm and blues, early rock, and soul music.

These posters are highly valued for their scarcity and historical importance. However, though they are often eye-catching, they are not intentionally beautiful. Concert posters from the early days of rock and the glory days of rhythm and blues and soul were functional objects, colorful pieces of cardboard advertising that had a specific and unsophisticated function. For the very reason that the posters were intended to be utilitarian rather than aesthetic, few survive today. The music these posters advertised was professional, but also very much of the grass roots. And while this music survived into the rock 'n' roll era of the 1960s, it predates white urban rock and figures as one

of its primary rural sources. The music was mostly performed in roadhouses known as "jukes," a term probably derived from *dzugu,* a Bambara word meaning "wicked," by way of the Gullah term *joog,* "disorderly." After the grind of a long work week, juke joints provided the setting for music, drinking, dancing, gambling, and love-making.

Up North, too, in cities like Chicago and Detroit, black music—and the black concert poster—flourished. During the 1940s the black population of the northern states increased dramatically. In 1940 there were 387,000 blacks in Illinois; by 1950, there were 645,000. In Michigan the population increased from 208,000 to 442,000. Throughout the 1950s, the black migration continued, the new urbanites bringing into Chicago and Detroit the music of the rural South, music that would influence the sound of the city even as city life exercised an influence on it. Country-born singers of an urban blues, like Muddy Waters, played such clubs as Smitty's Corner, Thirty-fifth and Indiana Avenue, Chicago. Howlin' Wolf gigged at the Big Squeeze Club, on the city's South Side. And there were many more, all playing music hard-driven by hard cities, but music nevertheless rooted in Mississippi mud, Georgia clay, and

the Cajun woods of East Texas and Louisiana. As they had in the South, posters went up all over Chicago, Detroit and elsewhere in the urban North.

A good blues, r & b, or soul poster actually says very little but speaks volumes. The few words leap out, the colors dazzle. At its best, the 1950s style was honest and straightforward, delivering its message with little if any embellishment. More sophisticated 1950s art associated with the birth of rock 'n' roll was done for the movies of the period. Window cards, along with larger lobby cards, were used by theaters across the country. Movies with titles like *Don't Knock the Rock* and *Rock Around the Clock* incorporated hits by black acts like Little Anthony and the Imperials or white groups like Bill Haley and the Comets, and inspired bold movie-poster art that lured teenagers by the thousands.

But even as the most successful of all rock movies—those featuring Elvis—reached their peak, rock 'n' roll music was beginning its first decline. Out of this early 1960s slow-down came the great folk-rock poet Bob Dylan, as well as the British Invasion and the overwhelming surge of Beatlemania.

The Command Performance poster, despite a wide early circulation, is a rare collectible piece today. Its original 1964 printing can fetch upward of $250. But another Beatles poster is virtually priceless today—the one advertising the 1965 Shea Stadium concert. More widely known is the Beatles concert poster done by San Francisco psychedelic artist Wes Wilson for the Candlestick Park show in 1966—the concert that turned out to be their last fully public event.

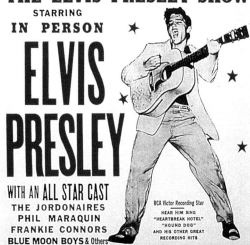

CINCINNATI GARDENS

One Show Only · 8:15 P.M.

Monday Night April 14

All seats Reserved · $2.00, 2.50, 3.00, 3.50

Tickets: Central Ticket Agency and Cincinnati Gardens Box Office

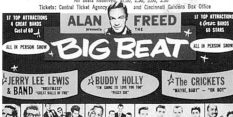

17 TOP ATTRACTIONS
4 GREAT BANDS
Cast of 60

17 TOP ATTRACTIONS
4 Great Bands
60 STARS

ALAN FREED presents THE

BIG BEAT

ALL IN PERSON SHOW

ALL IN PERSON SHOW

☆ JERRY LEE LEWIS & BAND "BREATHLESS" "GREAT BALLS OF FIRE"

☆ BUDDY HOLLY "I'M GOING TO LOVE YOU TOO" "PEGGY SUE"

☆ The CRICKETS "MAYBE, BABY" — "OH BOY"

☆ CHUCK BERRY "SWEET LITTLE 16" · "ROCK & ROLL MUSIC"

☆ FRANKIE LYMON "THUMB, THUMB"

☆ The DIAMONDS "THE STROLL"

☆ DANNY AND THE JUNIORS "AT THE HOP"

☆ BILLY & LILLIE "LA DEE DAH"

☆ Billy FORD AND THE THUNDERBIRDS

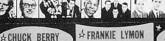

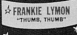

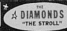

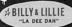

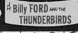

☆ The CHANTELS "MAYBE"

Larry WILLIAMS & ORCH.

The PASTELS

ALAN FREED and his BIG ROCKING BAND Starring SAM THE MAN TAYLOR New Hit! "BIG GUITAR"

CORAL RECORDS

☆ DICKY DOO AND THE DON'TS "CLICK CLACK"

☆ SCREAMIN' JAY HAWKINS "I PUT A SPELL ON YOU"

☆ JO ANN CAMPBELL

ED TOWNSEND "For You Love"

DIRECT FROM RECORD SMASHING N.Y. PARAMOUNT ENGAGEMENT

Alan Freed Presents the Big Beat
Cincinnati Gardens, Cincinnati, 1958

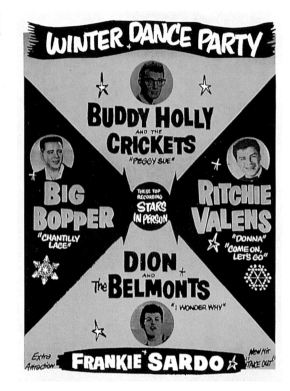

Winter Dance Party (Buddy Holly Final Tour)
Midwest, 1959

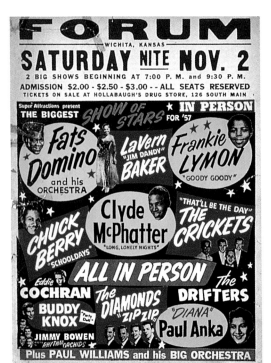

The Biggest Show of Stars for 1957
Forum, Wichita, Kansas, 1957
Artist: Globe Poster

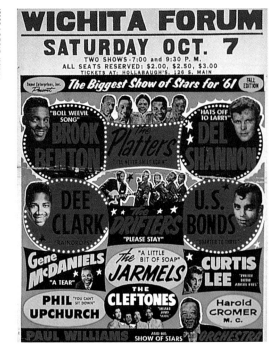

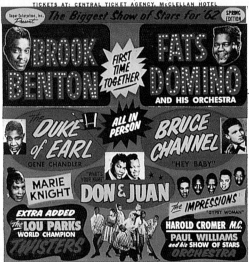

The Biggest Show of Stars for 1962
Forum, Wichita, Kansas, 1962
Artist: Globe Poster

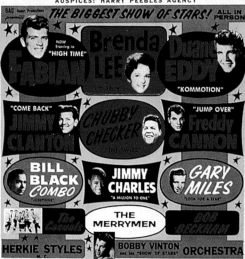

The Best Show in 1964
Ponce de Leon Ballpark, Atlanta, 1964
Artist: Posters Inc.

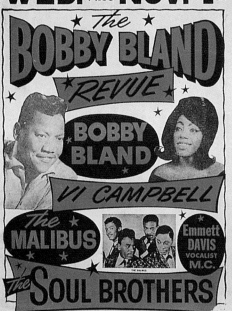

Bobby Bland; Vi Campbell
Embassy Room, East Palo Alto, California, 1967
Artist: Tilghman Press

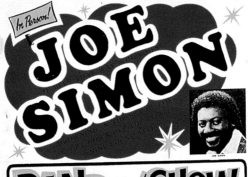

ZODIAC CLUB
7101 PURITAN AVE.--DETROIT, MICH.
(2 BLOCKS WEST OF LIVERNOIS)

FRIDAY, APR. 6
2 SHOWS--9:00 P.M. and 11:30 P.M.
Advance Admission $8.00--At Door $9.00

In Person!

JOE SIMON

JOE SIMON

BAND *and* SHOW

1801 Bvrd Street • Baltimore, Md. 21230 • Phone (301) 685-8767

Sam and Dave
Hide-A-Way Lounge, Nashville, 1980
Artist: Globe Poster

B. B. King
Pleasure Pier, Galveston, Texas, 1955
Artist: American Printing and Lithographic

Howlin' Wolf; Muddy Waters
Club Paradise, Memphis, 1964
Artist: Globe Poster

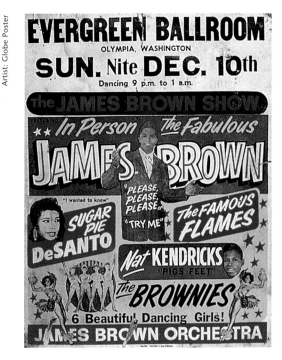

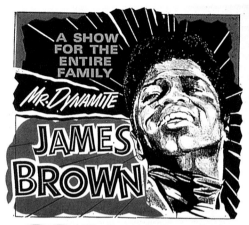

James Brown
Apollo Theatre, New York, 1966
Artist: Globe Poster

Temptations
Fillmore Auditorium, San Francisco, 1966
Artist: Tilghman Press

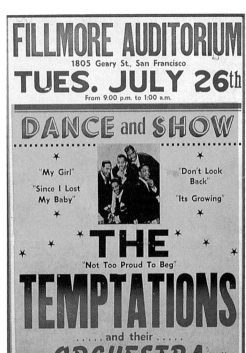

Four Tops; Johnny Talbot
Fillmore Auditorium, San Francisco, 1966
Artist: Tilghman Press

FILLMORE AUDITORIUM

1805 Geary St.　　　　San Francisco

ONE NITE ONLY

Tuesday, Sept. 27th

STARTS AT 9:00 P.M.

THE FOUR TOPS

★ "Reach Out I'll Be There"

★ "Baby I Need Your Loving"　　　★ "Ask The Lonely" ★

★ WITH ★

★ Johnny Tabot and De Thangs ★

DANCE ❋ CONCERT ❋ SHOW

TILGHMAN PRESS, 1707 - 23rd ST., OAK.

SPORTSMAN CLUB No. 2

5319 Grove St., Oakland

THUR. DEC. 9th

FROM 9:00 P.M. TO 1:00 A.M.

SHOW and DANCE

..... WITH

Marvin GAYE

"Ain't That Peculiar"

..... PLUS

★ *JOHNNY* ★
TALBOT

— FEATURING —

CURITS MARSHALL

★ and ORCHESTRA ★

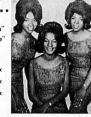

FILLMORE AUDITORIUM

1805 Geary St., San Francisco

★ ★ **LABOR DAY** ★ ★

MONDAY, SEPT. 5th

From 9:00 p.m. to 1:00 a.m.

DANCE and SHOW

"I'll Have To Let Him Go"

"Heat Wave" "Nowhere To Run"

"Wild One" "Quicksand" "Live Wire"

..... FEATURING

★ **Martha** ★

And The

VANDELLAS

..... PLUS

★ **SPECIAL APPEARANCE OF** ★

Johnny Talbot and De Thangs

TILLMAN PRESS, 107 33rd ST., OAK., 452-6300

Martha and the Vandellas
Fillmore Auditorium, San Francisco, 1966
Artist: Tilghman Press

RICHMOND CIVIC AUDITORIUM
SAT. Nite JAN. 11th
AT 8:30 P.M. RICHMOND, CALIFORNIA

IN SHOW and CONCERT

SAM
COOKE

BOBBY
BLAND
and his ORCHESTRA

AL BRAGGS ★ ELOISE HESTER

Admission: $3.00 - $3.50 - $4.00 Tickets on Sale at: Sherman Clay, Oakland
Music City Records - Reid's Records, Berkeley & Oakland - Melrose Records, S.F.
Breuners, Oakland, Richmond & Berkeley

EVERGREEN BALLROOM

OLYMPIA, WASHINGTON

SUN. OCT. 13th

DANCING 9 P.M. TO 1 A.M. Admission $3.00

IN PERSON ..

★ Jackie ★

Wilson

★

PLUS

The Upsetters

★ ORCHESTRA ★

Jackie Wilson: The Upsetters
Evergreen Ballroom, Olympia, Washington, 1963
Artist: Tilghman Press

ESTHER'S ORBIT ROOM

1753 - 7th Street Oakland, Calif.

SAT. MARCH 13th

★——★—·—★——★——★

featuring.... IN PERSON

MARY WELLS

Jubilee Recording Artist

"My Guy"

"Beat Me To The Punch"

Six Million Sellers

"Two Lovers"

"The One Who Really Loves You"

and her Revue

★—★——★——★——★

Smokey Robinson and the Miracles
Continental Club, Oakland, California, 1966
Artist: Tilghman Press

See The Mighty MIRACLES At

CONTINENTAL CLUB

1658 - 12th St., Oakland From 9 p.m. to 2 a.m.

WED. Nite, JUNE 1, 1966

SMOKEY ROBINSON
and the
★ ★ ★ ★
MIRACLES

"You Really Got A Hold On Me"
"Going To A-Go-Go"
"Mickey's Monkey"

and The Fabulous

BALLADS
"I Can't See Your Love"
— PLUS —

EDDIE FOSTER

Wally Cox, Terrible Tom Singing Many Great Hits
Advance Sale Tickets $2.50 At Door $3.00
Tickets On Sale At Music City Only ANOTHER FIELDS PROMOTION

TILGHMAN PRESS, INC., 33rd ST., OAKLAND, CALIF.

In Dance - Concert

THE
OTIS REDDING

1965's Number One R & B Male Vocalist - Cash Box Magazine Poll

★ **THREE NITES ONLY** ★

TUES., WED., THUR. **DEC. 20 - 21 - 22**

FILLMORE AUDITORIUM
Fillmore and Geary Sts.
SAN FRANCISCO

From 9:00 p.m. until ? ADMISSION $3.00

TILGHMAN PRESS, 827 - 22nd ST., OAK., 653-6060

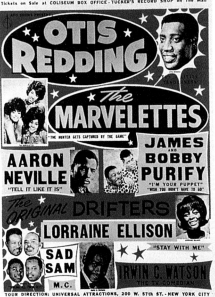

Otis Redding; The Marvelettes
Civic Coliseum, Knoxville, Tennessee, 1966
Artist: Globe Poster

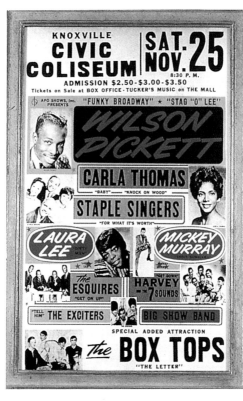

Ike and Tina Turner Revue
Oakland Auditorium, California; California Hall, San Francisco, 1967
Artist: Colby Poster

LIBERTY THEATRE

COLUMBUS - GA.

WED. JAN. 17

MATINEE - NITE - RAMBLE

THIS IS IT CATS!

THE TWIST The Dance - Craze That's Sweeping The Country

ON STAGE

IN PERSON **TWIST**

REVUE, CONTEST

CALLING ALL
HIP! HEP! TWISTIN' COUPLES

ENTER NOW · WIN! PRIZES · FAME & FORTUNE
HEAR TOP TWIST SONGS!

★ FREDDIE NORTH

Featured On DICK CLARK'S TV SHOW · SEE HIM · MEET HIM · IN PERSON

★ THE TWISTEROO'S HOT! HOT! COMBO DIRECT
FROM HARLEM'S HOT NIGHT SPOTS

★ DELLA & ELLA WINNERS of the 1962 "TWIST AWARD"

TWIST DANCERS SIGN UP FOR CONTEST TODAY

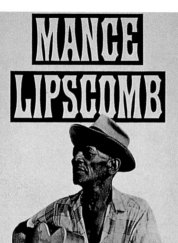

MANCE LIPSCOMB

TEXAS SONGSTER

Tuesday, Wednesday, Thursday — November 29, 30, Dec. 1

THE JABBERWOCK

2901 Telegraph Avenue Berkeley

for reservations & information — TH 5-9619

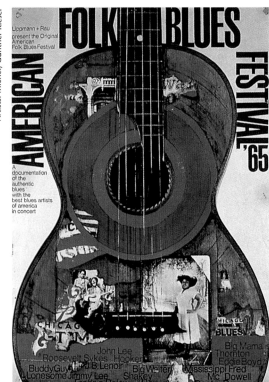

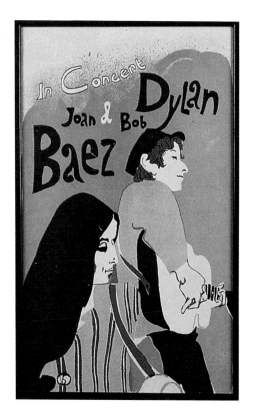

Joan Baez and Bob Dylan
East Coast Tour, 1965
Artist: Eric Von Schmidt

Mitch Ryder and the Detroit Wheels
Civic Center, The Dalles, Washington, 1964
Artist: Tilghman Press

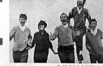

The Byrds; We Five
Municipal Auditorium, Nashville, 1965
Artist: Hatch Show Print

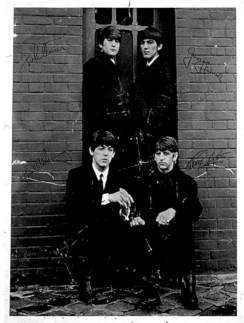

LEACH ENTERTAINMENTS PRESENT

OPERATION BiG BEAT - 5TH

AT THE

TOWER BALLROOM NEW BRIGHTON
FRI. 14TH SEPT. 7·30 - 1·0 A.M.

FEATURING AN ALL STAR 6 GROUP LINE UP · STARRING
THE NORTH'S TOP ROCK COMBO, APPEARING AT 10·30 PROMPT

The BEATLES

RORY STORM WITH THE Hurricanes

GERRY AND THE PACEMAKERS THE 4 JAYS
BILLY KRAMER WITH THE COASTERS THE MERSEY BEATS

TICKETS **5/-**

★ LICENSED BARS (UNTIL 12·15 A.M.)

★ LATE TRANSPORT (ALL AREAS L'POOL & WIRRAL)
COACHES LEAVE ST. JOHN'S LANE/LIME ST. 7·00-8·30 P.M.
FROM
RUSHWORTHS · NEMS · CRANES · STROTHERS
LEWIS'S · TOP HAT RECORD BAR · TOWER BALLROOM

The Beatles—Operation Big Beat #5
Tower Ballroom, New Brighton, England, 1962

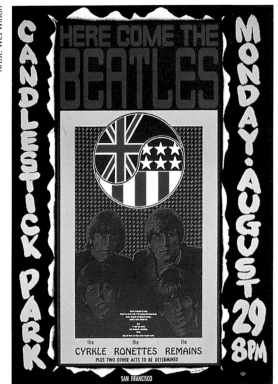

Final Concert Appearance: The Beatles
Candlestick Park, San Francisco, 1966
Artist: Wes Wilson

2.
THE PSYCHEDELIC YEARS
IN SAN FRANCISCO

The 1960s posters were where fine art and commercial art met. It was a great time—it meant breaking all the rules.

STANLEY MOUSE
to the San Francisco *Chronicle,* April 9, 1987

As the decade of the 1950s gave way to the 1960s, no sage could foresee the sweeping changes that were about to take place. The 1950s had seen some social rebellion, expressed popularly in such films as *Rebel Without a Cause* and even in early rock 'n' roll, but despite cold war, world unrest, and civil rights protests, America's mood was quiescent. It proved to be the lull before the storm.

As late as 1963, little that was new had erupted on the American rock 'n' roll front, and there were no new forms of concert poster art to suggest that a revolutionary era was in the making. But by the next year, quietly at first,

clutches of radically minded young people had begun to establish themselves on the West Coast. During that same year, excitement over developments in British rock—especially the Beatles—was growing. Musically, the United States was about to be invaded by the British. That onslaught would in turn unleash American musical forces just as powerful.

What came to pass was heralded by a gradual, almost volitionless migration of hip young Americans to the beckoning haven of San Francisco. This gathering began to stoke up the sputtering fires of American rock 'n' roll. Part of this revitalization was the development of an entirely new genre of art: the psychedelic rock poster.

San Francisco's KYA radio station broadened its format with hearty doses of the emerging British rock along with classic r & b. In 1963 KYA's top disc jockeys Tom Donohue and Bobby Mitchell formed a partnership that led to their producing a sold-out show at the 18,000-seat Cow Palace; it headlined the Beach Boys, list-topping Motown acts, and classic fifties rockers. Donohue also briefly ran a rock club known as Mothers, where the featured attraction during one eye-opening week in 1965 was the Lovin' Spoonful, America's answer to Britain's Gerry and the Pacemakers.

Even more important that year (on May 14) was San Francisco's first experience of the Rolling Stones, who really opened people's ears. And the city was about to find a new pet—a psychedelic canine known as the Family Dog.

It started with a very mod, stylish American Edwardian named George Hunter. While at San Francisco State, Hunter became involved with sophisticated audio electronics and produced a number of free-form "happenings." After meeting musicians Mike Wilhelm, Richard Olsen, and, later, Dan Hicks and Michael Ferguson, Hunter emerged as the leader of a folk-rock novelty band, the Charlatans.

In late spring 1965, Chandler Laughlin, bartender at the Red Dog Saloon in Virginia City, Nevada, began to look for a band that would fit into the Wild West dance hall he and Mark Unobsky envisioned for the old Comstock House Unobsky had bought. Although the group was just learning how to play musical instruments, the Charlatans were ideal. In June the band traveled to Virginia City and auditioned—on acid—to the great amusement of those gathered. The summer-long engagement that followed has become celebrated as the birth of America's psychedelic era.

The Charlatans' Red Dog engagement occasioned the

first rock poster of the psychedelic era. It was dubbed "The Seed" in *Art Eureka,* an early poster book, and the name has stuck. In the catalog for the poster show he produced in 1976 at San Francisco's Museum of Modern Art, rock-poster historian Walter Medeiros wrote: "The Seed is unique for being completely hand-drawn, in a densely-patterned format, and was much different from rock posters that existed then." George Hunter came up with the poster's distinctive logo incorporating the band's name, but it was piano player Michael Ferguson who drew the caricatures and decorations that create the old-timey feel.

As fall approached, there were stirrings of interest about putting on Red Dog–like happenings in San Francisco, stirrings that emanated partly from some people living cooperatively in a house at 2111 Pine Street, across town from the Haight. Those people became the Family Dog, which came to include others united by a common interest in ecology, politics, early protests against the Vietnam War, drugs, and—finally—music. When the Family Dog decided to put on rock dances, Alton Kelley (an early inmate of the Dog House who had moved to San Francisco from Connecticut in 1964) designed the promotional posters.

First run by Luria Castell, the cooperative was

acquired by Chet Helms, manager of Big Brother and the Holding Company, and his partner, John Carpenter. The pair had staged shows featuring Big Brother at Berkeley's Open Theater. He wanted to try his chops on something more public and arranged with Castell to book Big Brother at a Family Dog dance in California Hall. But when Castell left, the date fell through, and Helms had to look for an alternative. He went to Carpenter's friend Bill Graham, who offered the Fillmore on alternate weekends. Family Dog Productions was born.

Helms and Carpenter approached Bill Graham because he had been producing successful dance benefits for the San Francisco Mime Troupe. He served as the troupe's business manager and factotum after having left a lucrative management position with the Allis-Chalmers Manufacturing Company late in 1964. The next two years saw Mime Troupe shows and, in 1966, the epoch-making Trips Festival. Although naturalist Stewart Brand and Ken Kesey's Merry Pranksters, along with various leading musicians, actually conceptualized this three-day event—which firmly established psychedelia in San Francisco—it was Graham who capitalized on its possibilities. He went into business for himself. The weekend following the Trips

Festival, he produced his first show, the poster for which makes prominent mention of the festival's "sight and sounds," which people could experience once again at the Fillmore. Two weeks later, Helms and company produced their own first dance, and for the next two and a half months, Graham and the Family Dog shared the Fillmore.

They also shared the same poster artist. Wes Wilson, who had attended San Francisco State and dabbled in philosophy, was working at Contact Printing, a small San Francisco press that had handled jobs for the Mime Troupe. Before doing the first Graham and Family Dog posters, Wilson had executed Helms's handbills for his Open Theater shows, as well as the handbill and program for the Trips Festival. Except for Graham's very first poster (done by Peter Bailey, another artist associated with the Mime Troupe) and perhaps one or two others, Wilson handled all of Graham's work through early May 1967.

Some of the thematically strong early Family Dog posters became known by such titles as "Euphoria," "Hupmobile 8," or "The Quick and the Dead." Later on, as the posters became more popular and were made available for retail sale, the Family Dog staff assigned code names, much like Helms's early titles, to all the posters in

the series. The margins of some Family Dog posters also contain cryptic messages. Most famous of all is the one on FD 5: "May the Baby Jesus shut your mouth and open your mind." Helms claimed to have found it on a bathroom wall. The phrase was also keyed to the Family Dog's logo, which Wilson designed using as the central image a photo of an Indian fur trader smoking a long-stemmed pipe that the artist modified to look like a joint.

Stanley Miller (formerly of Detroit and better known as Stanley Mouse or simply Mouse) succeeded Wes Wilson as the Family Dog's artist-in-residence. Wilson had executed eleven of the first twelve Family Dog posters, Victor Moscoso did the twelfth, and Mouse began with FD 13, for a Captain Beefheart appearance at the Avalon in mid-June 1966. He was responsible—alone or in collaboration with associate Alton Kelley—for twenty-six of the next thirty-six Family Dog posters during a nine-month period that firmly established the "psychedelic" style as an expression of the times. Mouse was already highly regarded as an artist on the hot-rod-show circuit, before settling in San Francisco during the Haight-Ashbury heyday. His weapon of choice was the airbrush, with which he produced hot-rod-era cartoons that brought him early

grass-roots fame. The techniques he evolved on the road served him well when he turned his hand to rock posters.

According to Walter Medeiros, while Mouse did the lettering and graphics, and Alton Kelley provided the photos and collages, "virtually all the posters signed 'Mouse Studios' were the combined work of both artists." While Kelley's specialty was the collage, this technique was used very little in Kelley-Mouse rock posters. What most characterized their work, Medeiros suggests, is "a healthy sense of irreverence toward narrow proprietary values." They freely appropriated classic trademark images, as in "Zig Zag Man," which exploited the Zig Zag cigarette paper logo. For them, such commercial pop "images . . . existed out in the world . . . like words in a dictionary."

It was Mouse and Kelley's Family Dog posters that apparently triggered Rick Griffin's interest in rock art and induced him in 1966 to move to San Francisco. His art was influenced by the culture of the American West; another key influence was surfing. Born on the Southern California coast, Griffin came to love the sport at a very early age. By the end of high school, in the late 1950s, he had developed his own surfer cartoon figure called "Murphy." After graduation, Griffin joined the staff of filmmaker John

Severson's *Surfer Magazine* and briefly attended art school. There he met a group of traveling artist-musicians called the Jook Savages, an early hipster tribe that influenced some of his later thinking. Meanwhile, the Murphy character appeared in *Surfer*—and before long became the best-known cartoon figure in the surfing movement, reaching all corners of the globe via decals and T-shirts.

While still in Los Angeles in early 1966, Griffin and the Jook Savages took part in one of Ken Kesey's experimental gatherings, the Watts Acid Test, which featured the newly emergent Grateful Dead. Combined with his exposure to Mouse and Kelley's work, it whetted Griffin's appetite for the new San Francisco scene, and he headed up the Coast. In 1965 he had seen the Charlatans at the Red Dog Saloon and knew some of the leading members of San Francisco hip society, but what was happening in the fall of 1966 really turned his head around. Walter Medeiros sees affinities between Griffin's art and that of the Charlatans' George Hunter and Michael Ferguson as well as Mouse and Kelley. All explored the revival of nineteenth-century graphics and American advertising motifs.

One other San Francisco poster artist achieved renown for his use of striking, shimmering bright color. This was

Victor Moscoso, a transplanted New Yorker who was one of the few psychedelic artists with extended and substantial formal art training. Like Griffin, Moscoso produced posters that have an instantly apparent "feel" all their own.

While Family Dog ended its numbered series of posters late in 1968, Bill Graham carried his production into the summer of 1971. As was the case with Family Dog and Cal Litho, Graham developed a strong personal relationship with his printer, Levon Mosgofian, owner of Tea Lautrec Litho. Moreover, Mosgofian developed close working relationships with the artists Graham commissioned. Whereas the printer was virtually autonomous in the prepsychedelic days of the rock poster—before 1965 taking on the roles of art director, artist, and printer—the complexities of psychedelic art called for sensitive collaboration among promoter, artist, and printer.

Corny as it may seem at this cultural remove, the posters were a labor of love. The rock posters of the psychedelic years were not commercialized in the manner of other American icons. It is possible still to feel a special reverence for them, and even as the posters were being created, those involved in their creation as well as all those standing by felt a sense of kinship with the poster artists at work.

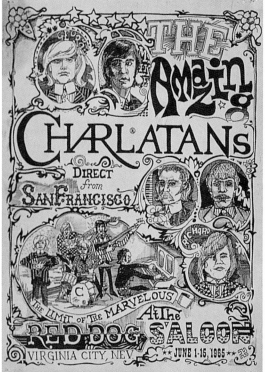

Charlatans ("The Seed," original version)
Red Dog Saloon, Virginia City, Nevada, 1965
Artists: George Hunter, Michael Ferguson

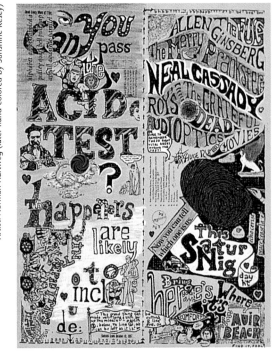

Can You Pass The Acid Test?
Muir Beach, California, 1965
Artist: Norman Hartweg (later hand-colored by Sunshine Kesey)

THE FAMILY DOG

Those new members of a great tradition, The
The American Taste
PRESENTS A Oct 24 & 12

DANCE

and Concert of sorts, with
the rigorus ancestral strains of the...

(splendid, flashing)

LOVIN SPOONFUL

a slightly apple-cheeked illusion, those

CHARLATANS Longshoremens
 Hall
LARRY MAHEN'S

Russ Symond & a gaggering of a

Pearl

a marvelous good way to spure it etch

A Tribute to Sparkle Plenty (foil poster)
Longshoremen's Hall, San Francisco, 1965
Artist: Alton Kelley

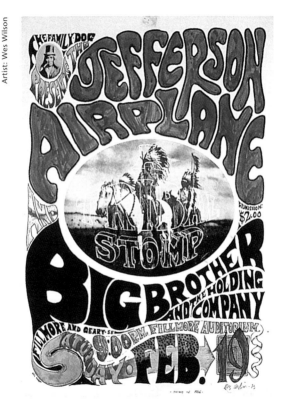

Family Dog #1 (hand-colored version)
Fillmore Auditorium, San Francisco, 1966
Artist: Wes Wilson

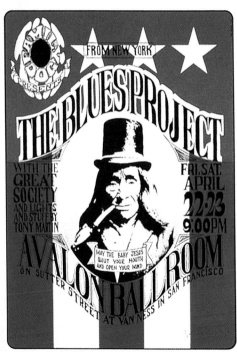

Family Dog #5
Avalon Ballroom, San Francisco, 1966
Artist: Wes Wilson

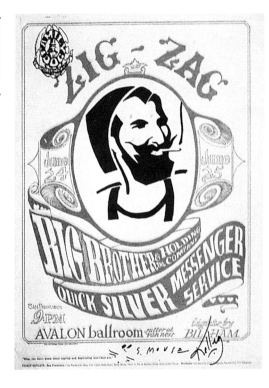

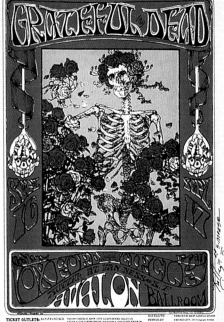

Family Dog #26
Avalon Ballroom, San Francisco, 1966
Artists: Stanley Mouse, Alton Kelley

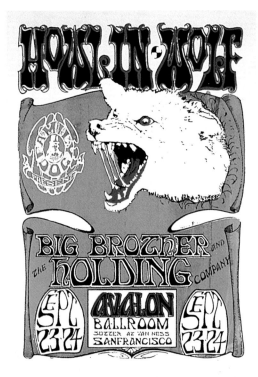

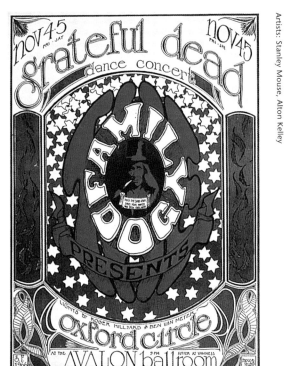

Family Dog #33
Avalon Ballroom, San Francisco, 1966
Artists: Stanley Mouse, Alton Kelley

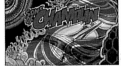

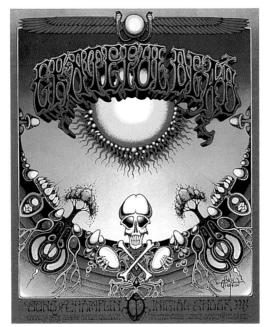

Grateful Dead ("Aoxomoxoa")
Avalon Ballroom, San Francisco, 1969
Artist: Rick Griffin

S.F. MIME TROUPE
APPEAL II
FOR CONTINUED ARTISTIC FREEDOM IN THE PARKS
DANCE - CONCERT
=== WITH ===

JEFFERSON AIRPLANE

JOHN HANDY QUINTET

SAM THOMAS & THE GENTLEMEN'S BAND

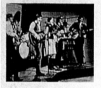

THE MYSTERY TREND

THE GREAT SOCIETY

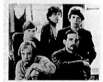

AND
MANY
OTHER
FRIENDS

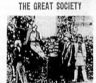

FRIDAY, DECEMBER 10
9 P.M. TILL ?
FILLMORE AUDITORIUM
FILLMORE & GEARY STREETS

DONATIONS - $1.50 INFORMATION: GA 1-1984

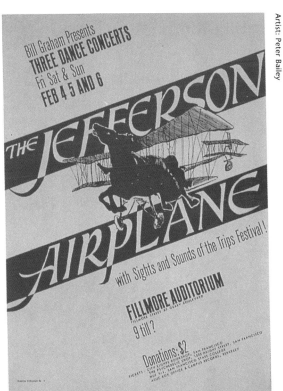

Bill Graham #1
Fillmore Auditorium, San Francisco, 1966
Artist: Peter Bailey

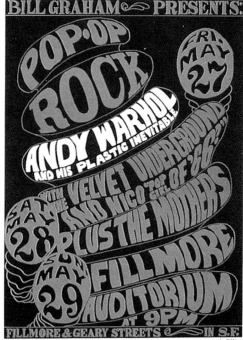

Bill Graham #8
Fillmore Auditorium, San Francisco, 1966
Artist: Wes Wilson

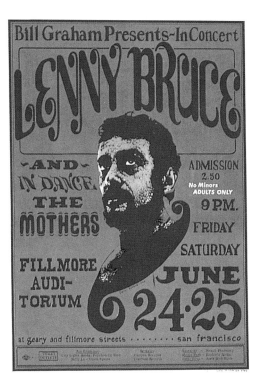

Bill Graham #13
Fillmore Auditorium, San Francisco, 1966
Artist: Wes Wilson

PRESENTED BY BILL GRAHAM IN SAN FRANCISCO

THEM

with the

SONS OF
CHAMPLIN

FRIDAY SATURDAY

29 JULY 30

FILLMORE

AUDITORIUM

TICKET OUTLETS	San Francisco	Berkeley	Mill Valley
	City Lights Book Store	Discount Records	The Mad Hatter
	Psychedelic Shop	Shakespeare & Co.	
Starts at 9 pm	Bally Lo – Union Square	Campus Records	Sausalito
	Town Squire – 13th Polk		Tidell Pharmacy
	Mnasidika – 1510 Haight		

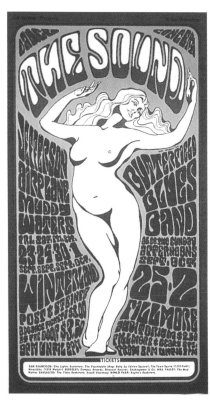

Bill Graham #29
Winterland/Fillmore Auditorium, San Francisco, 1966
Artist: Wes Wilson

Bill Graham #37
Fillmore Auditorium, San Francisco, 1966
Artist: Wes Wilson

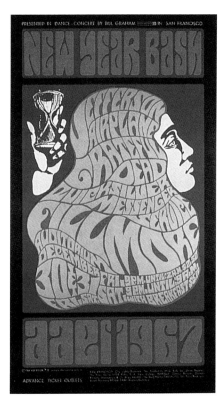

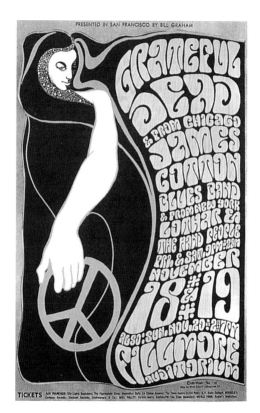

Bill Graham #38
Fillmore Auditorium, San Francisco, 1966
Artist: Wes Wilson

Bill Graham #47
Fillmore Auditorium, San Francisco, 1967
Artist: Wes Wilson

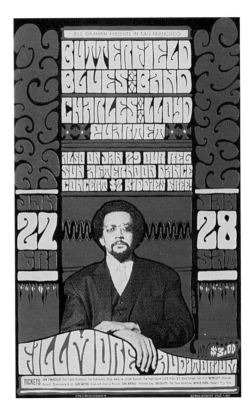

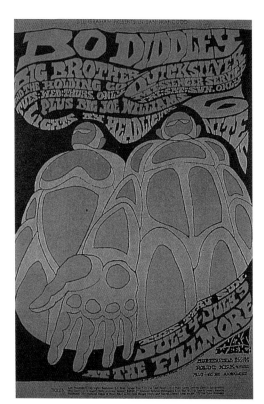

Bill Graham #71
Fillmore Auditorium, San Francisco, 1967
Artist: Bonnie MacLean

Bill Graham #74
O'Keefe Centre, Toronto, 1967
Artist: James H. Gardner. Photographer: Herb Greene

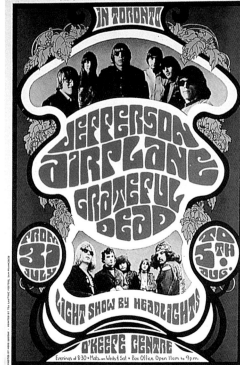

Bill Graham #90
Fillmore Auditorium, San Francisco, 1967
Artist: Bonnie MacLean

Bill Graham #93
Fillmore Auditorium/Winterland, San Francisco, 1967
Artist: Jim Blashfield

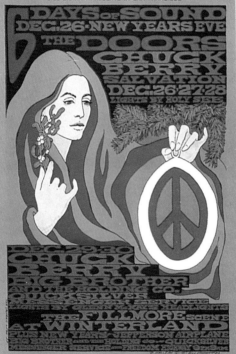

Bill Graham #99
Winterland, San Francisco, 1967
Artist: Bonnie MacLean

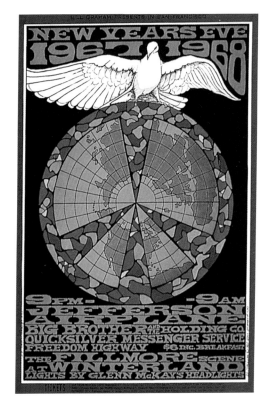

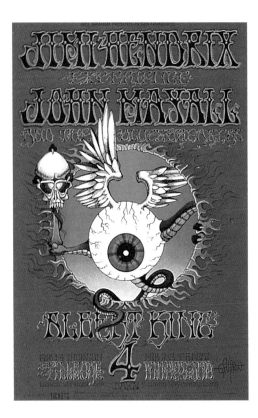

Bill Graham #105
Fillmore Auditorium/Winterland, San Francisco, 1968
Artist: Rick Griffin

Bill Graham #119
Fillmore Auditorium, San Francisco, 1968
Artist: Weisser

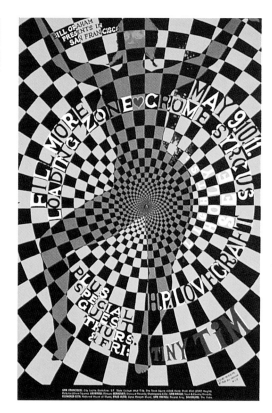

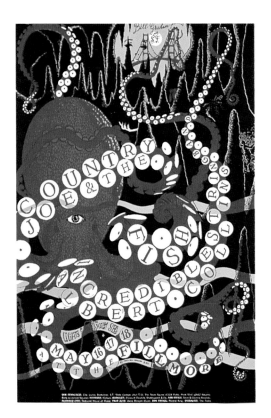

Bill Graham #120
Fillmore Auditorium, San Francisco, 1968
Artist: Weisser

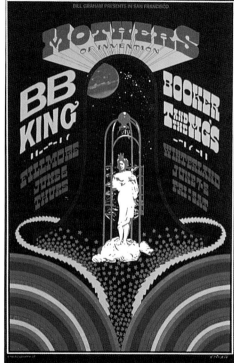

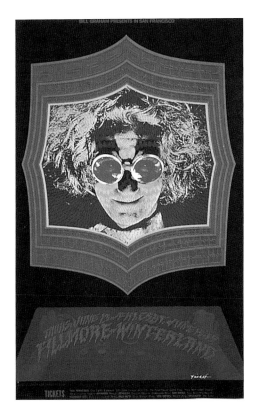

Bill Graham #124
Fillmore Auditorium/Winterland, San Francisco, 1968
Artist: Bob Fried

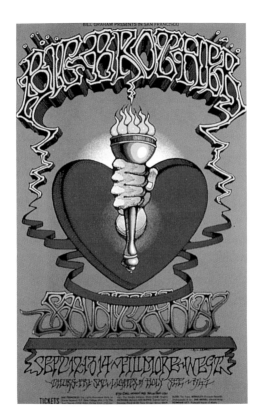

Bill Graham #140
Winterland, San Francisco, 1968
Artists: Rick Griffin, Victor Moscoso

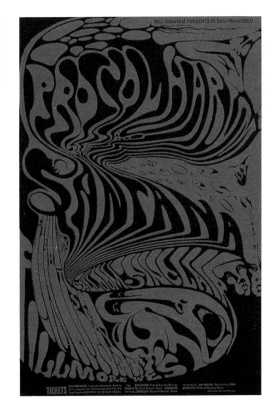

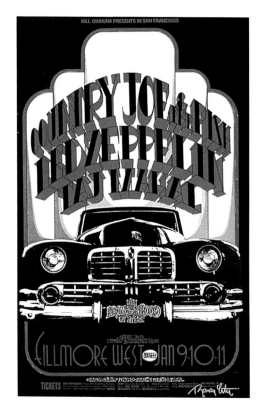

Bill Graham #155
Fillmore West, San Francisco, 1969
Artists: Randy Tuten, D. Bread

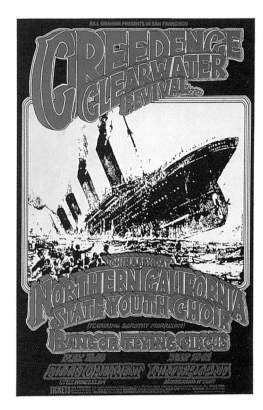

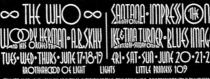

Bill Graham #178
Fillmore West, San Francisco, 1969
Artist: David Singer

Bill Graham #186
Cow Palace, San Francisco, 1969
Artist: Randy Tuten

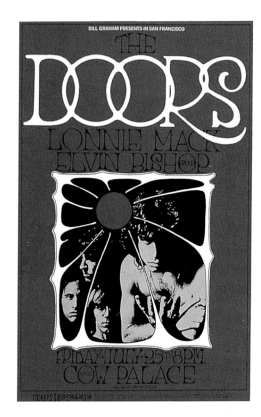

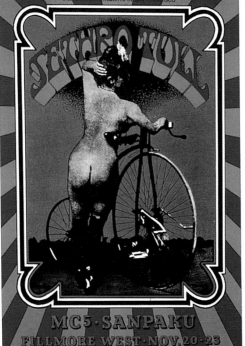

Bill Graham #203
Fillmore West, San Francisco, 1969
Artist: Randy Tuten

Bill Graham #207
Winterland, San Francisco, 1969
Artist: David Singer

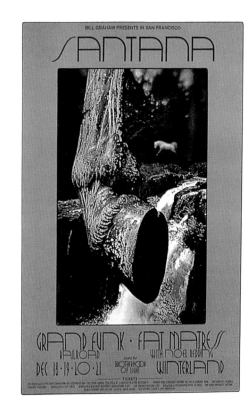

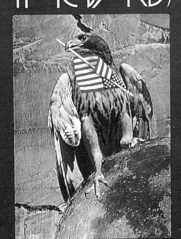

Bill Graham #210
Fillmore West, San Francisco, 1970
Artist: David Singer

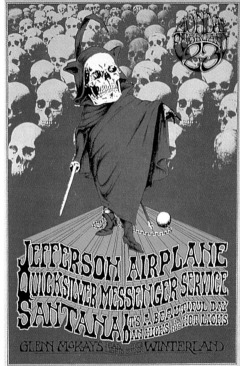

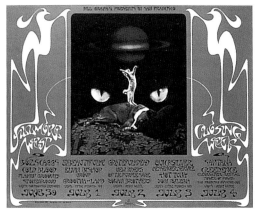

Bill Graham #287
Fillmore West, San Francisco, 1971
Artist: David Singer

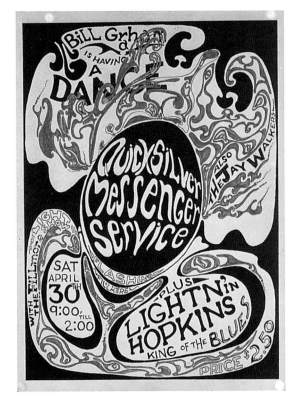

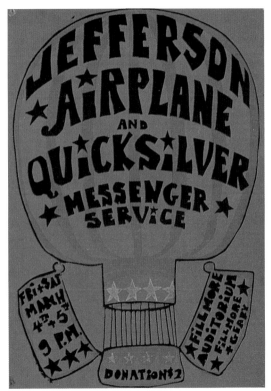

Quicksilver Messenger Service (silk-screen poster)
Fillmore Auditorium, San Francisco, 1966
Artist: Bob Collins

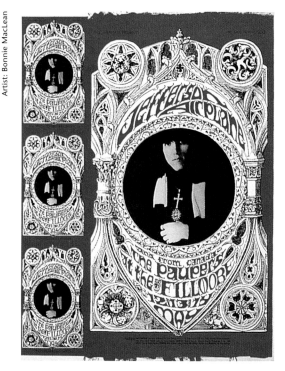

Bill Graham #63 (uncut progressive proof)
Fillmore Auditorium, San Francisco, 1967
Artist: Bonnie MacLean

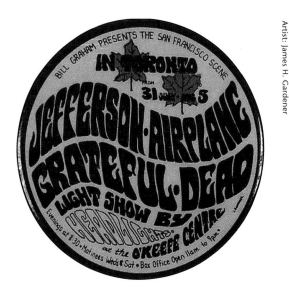

Button: Jefferson Airplane; Grateful Dead
O'Keefe Centre, Toronto, 1967
Artist: James H. Gardener

Third Annual Children's Adventure Day Camp Benefit
Fillmore Auditorium, San Francisco, 1966
Artist: Mary Kay Brown

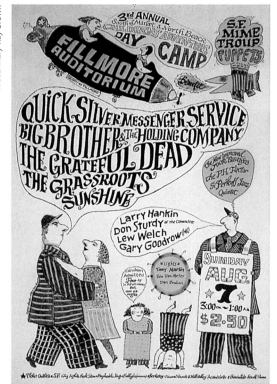

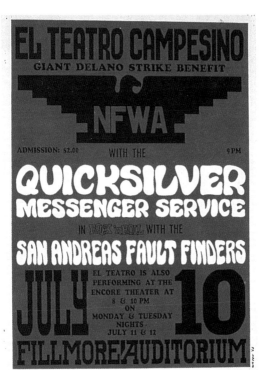

Delano Strike Benefit
Fillmore Auditorium, San Francisco, 1966
Artist: Wes Wilson

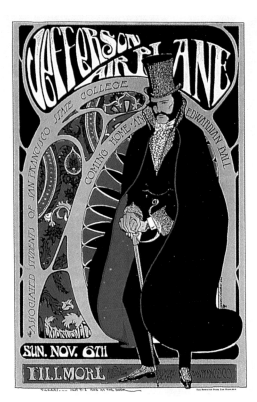

Edwardian Ball
Fillmore Auditorium, San Francisco, 1966
Artists: Stanley Mouse, Alton Kelley

Jimi Hendrix Experience
Fillmore East, New York, 1968
Artist: Fantasy Unlimited

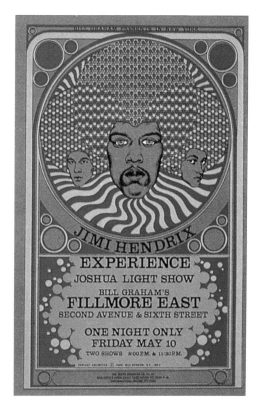

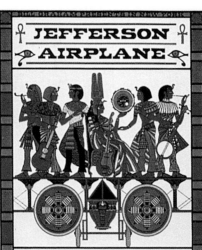

LIGHTNING HOPKINS

THE KING OF THE BLUES

Only Northern Calif. Appearance
TUES., SEPT. 21 thru SUN., SEPT. 26
The MATRIX
3138 FILLMORE ST., S.F. 567-0118
also JEFFERSON AIRPLANE
COVER CHARGE: TUES, WED, THURS, & SUN. $1.00 FRI. & SAT. $1.50

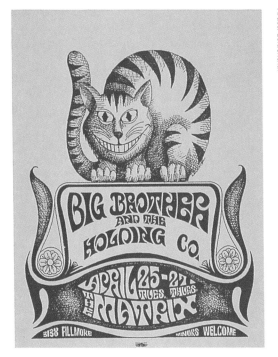

Big Brother and the Holding Company
The Matrix, San Francisco, 1967
Artist: Leidenthal

Big Brother and the Holding Company
The Matrix, San Francisco, 1966
Artist: Stanley Mouse

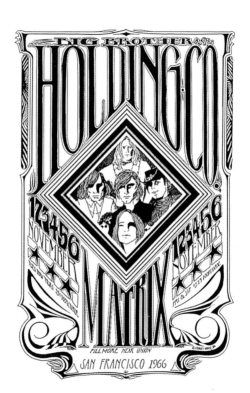

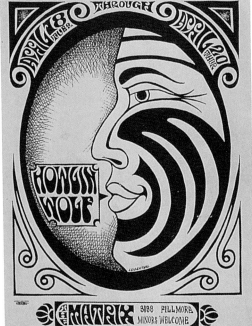

Howlin' Wolf
The Matrix, San Francisco, 1967
Artist: Leidenthal

Jefferson Airplane; William Penn and His Pals
Civic Auditorium, San Francisco, 1966

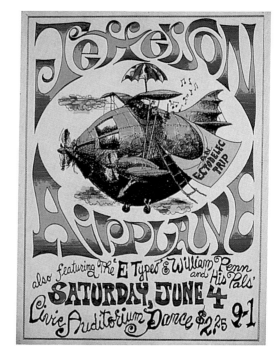

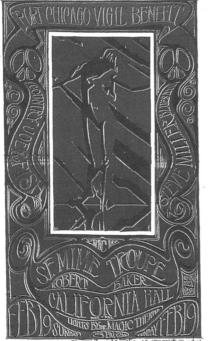

Port Chicago Vigil Benefit
California Hall, San Francisco, 1967
Artist: Stanley Mouse

Strange Happenings
California Hall, San Francisco, 1967
Artist: Greg Irons

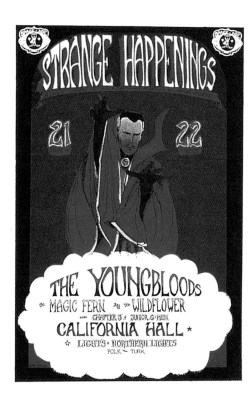

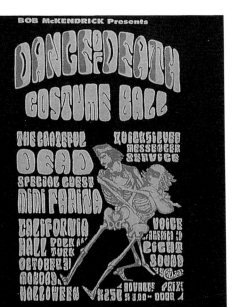

Dance of Death Costume Ball
California Hall, San Francisco, 1966

Big Brother and the Holding Company
California Hall, San Francisco, 1967
Artist: Michael Wood/Pyxis Studios

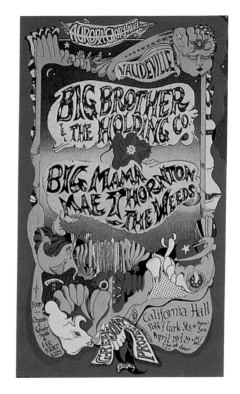

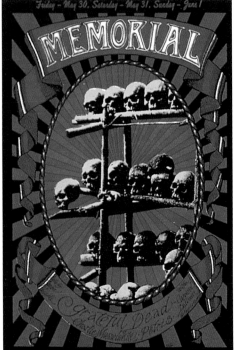

Grateful Dead "Memorial"
Carousel Ballroom, San Francisco, 1969
Artist: Alton Kelley

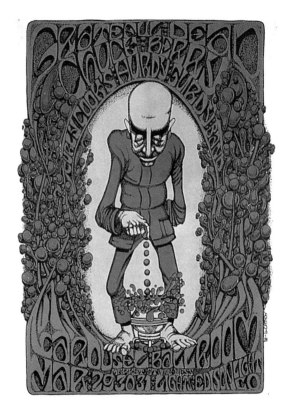

Grateful Dead; Chuck Berry
Carousel Ballroom, San Francisco, 1968
Artist: Steven Catron

Grateful Dead "Sore Thumb"
Carousel Ballroom, San Francisco, 1968
Artist: Alton Kelley

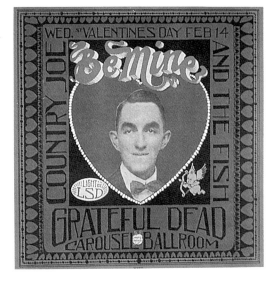

Grateful Dead "Be Mine"
Carousel Ballroom, San Francisco, 1968
Artist: Stanley Mouse

Big Brother and the Holding Company (Saturday night ticket)
Carousel Ballroom, San Francisco, 1968
Artist: Crazy Arab

Grateful Dead "Zenefit"—Zen Mountain Center Benefit
Avalon Ballroom, San Francisco, 1966
Photographer: Robert Bono

"Trip or Freak"
Winterland, San Francisco, 1967
Artists: Stanley Mouse, Alton Kelly, Rick Griffin

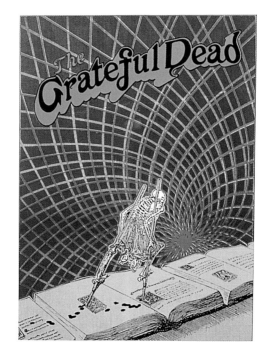

Grateful Dead (translucent poster), 1967
Artist: Bob Fried

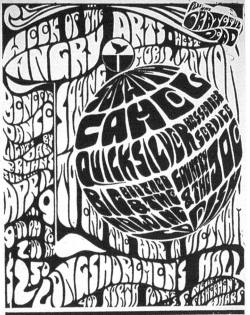

Week of the Angry Arts—Vietnam Mobilization

Longshoremen's Hall, San Francisco, 1966

Dance and Show

KYA SUPER HARLOW A GO-GO

. presents

THE VEJTABLES

★

"I Still Love You" "The Last Thing on My Mind"

★ 4 BIG BANDS ★

BAYTOVENS

★ *JUST SIX* ★

"BO SAID"

William Penn
and his Pals
★

SAT. Nite JANUARY 8, 1966

From 8 p.m. to Midnite

LONGSHOREMEN'S HALL

(FISHERMAN'S WHARF) 301 Beach St., San Francisco

Free Records to the First 300 at Door

Admission $2.00 DRESS CASUAL

TILGHMAN PRESS, INC., 2nd ST., OAK - 654-0091

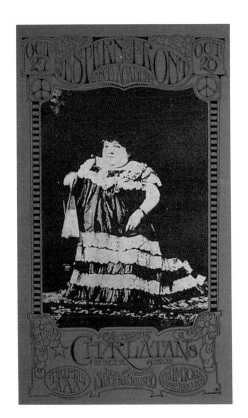

Charlatans; Frumious Bandersnatch
Western Front, San Francisco, 1966
Artist: Stanley Mouse

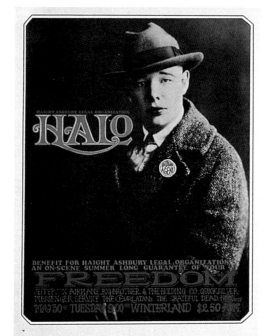

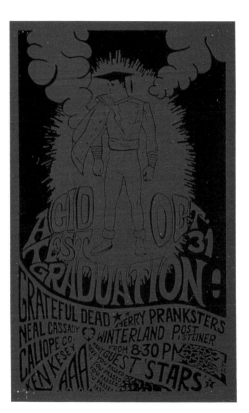

Acid Test Graduation
Winterland, San Francisco, 1966
Artist: Gut

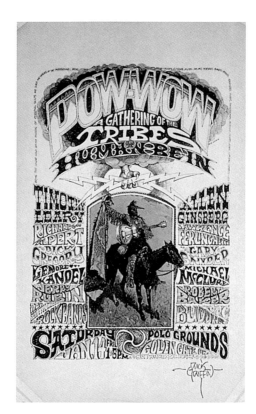

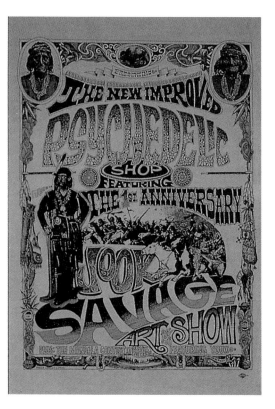

The New Improved Psychedelic Shop and Jook Savage Art Show
San Francisco, 1966
Artist: Rick Griffin

Steve Miller; Little Richard
Straight Theater, San Francisco, 1967
Artist: Randy Salas

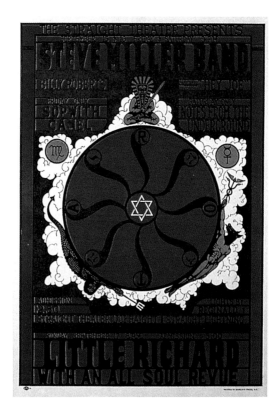

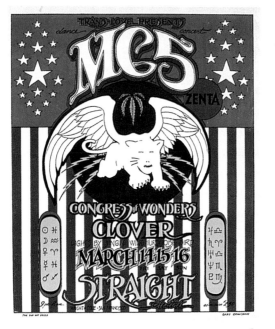

MC5; Clover
Straight Theater, San Francisco, 1969
Artist: Gary Grimshaw

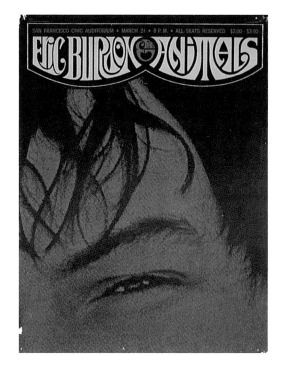

Eric Burdon and the Animals
Civic Auditorium, San Francisco, 1967
Artist: Sparta Graphics

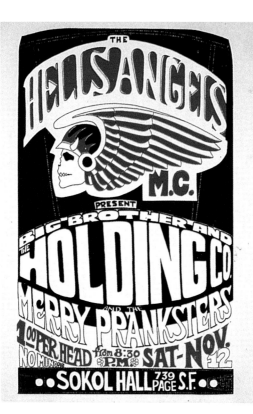

Hells Angels Dance
Sokol Hall, San Francisco, 1966

KSAN Radio Promotion (proof)
San Francisco, 1969
Artists: Rick Griffin, Alton Kelley

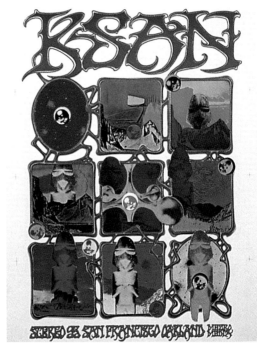

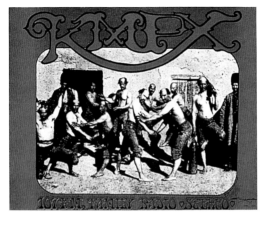

KMPX Radio Promotion
San Francisco, 1967
Artists: Stanley Mouse, Alton Kelley

Leander Productions *Present . . .*

★

THEM

In Concert

KYA's TONY BIGG as M.C.

. . . . Also

THE THE
ASSOCIATION ★ **GRASSROOTS**

The BAYTOVENS The WILDFLOWER
The HARBINGER COMPLEX
★ WM. PENN & His PALS ★

OAKLAND AUDITORIUM ARENA

SUN., JUNE 26th - At 8:15 p.m.

TICKETS AVAILABLE AT: Sherman Clay, Oakland, Hayward
Tickets - $2.50 - $3.50 - $4.50

TILGHMAN PRESS, 1847 - 33rd ST., OAK - 482-0080

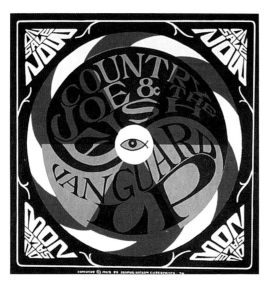

Vanguard Album Promotion: Country Joe and the Fish
Berkeley, California, 1967
Artist: Tom Weller

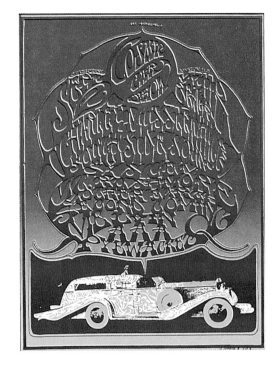

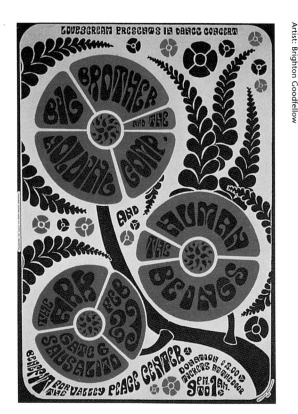

Big Brother and the Holding Company; Human Beings
The Ark, Sausalito, California, 1967
Artist: Brighton Goodfellow

Grateful Dead; Moby Grape
Armory, Santa Venetia, California, 1966
Artist: Tilghman Press

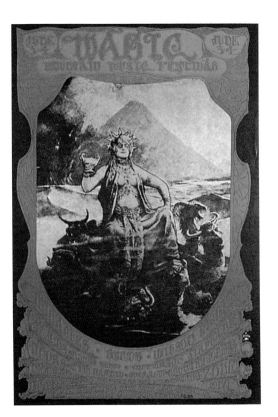

Magic Mountain Festival
Mt. Tamalpais, Marin County, California, 1967
Artist: Stanley Mouse

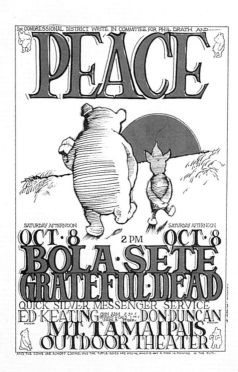

Bola Sete; Grateful Dead ("Peace," version 3)
Mt. Tamalpais Outdoor Theater, Marin County, California, 1966
Artists: Stanley Mouse, Alton Kelley

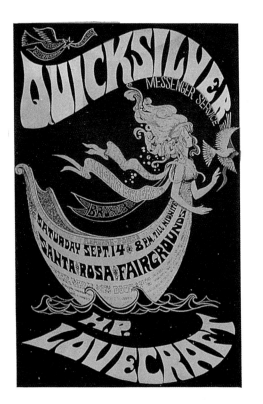

Quicksilver Messenger Service, H. P. Lovecraft
Fairgrounds, Santa Rosa, California, 1968

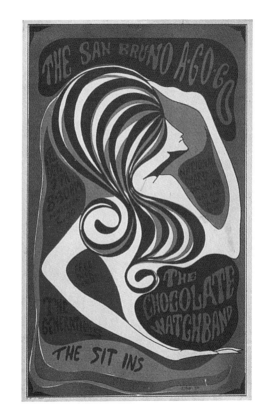

Chocolate Watchband; Generations
National Guard Armory, San Bruno, California, 1966
Artist: C. Thayer

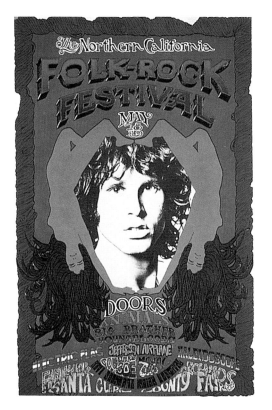

Northern California Folk-Rock Festival
Fairgrounds, Santa Clara, California, 1968
Artist: Carson-Morris Studios

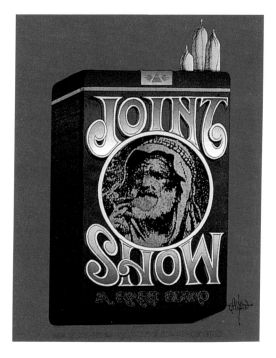

Joint Show
Moore Gallery, San Francisco, 1967
Artist: Rick Griffin

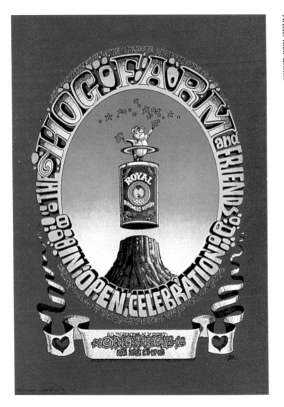

Hog Farm Celebration
Cinematique 16, Los Angeles, c. 1969
Artist: Rick Griffin

Allen Ginsberg Broadside
San Francisco, 1967
Artist: Wes Wilson

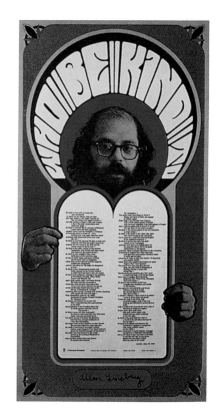

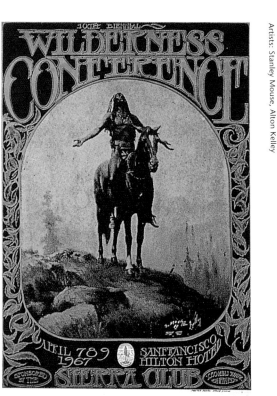

Wilderness Conference
Hilton Hotel, San Francisco, 1967
Artists: Stanley Mouse, Alton Kelley

3.
THE PSYCHEDELIC YEARS IN SOUTHERN CALIFORNIA AND THE REST OF THE WORLD

This time it was the native American bands which took us the one huge step closer to the future we had always been headed for. It was the Jefferson Airplane, the Grateful Dead, Big Brother and the Holding Company, Country Joe and the Fish, Quicksilver Messenger Service, the Great Society, the Fugs, the Mothers of Invention, Captain Beefheart and his Magic Band—all these great weirdo conglomerations of native-born maniacs who seemed to rise out of nowhere to sing the new truths we had already begun to live.

JOHN SINCLAIR
Guitar Army

It was West Coast rock in 1965 that first posed a threat to the British Invasion. Then, over the next two years,

American "psychedelic" rock swept across the country. Young people everywhere were caught up in a massive reorganization of values and life-styles, and the cultural influence of psychedelic rock would far surpass the impact of 1950s rock 'n' roll.

By mid 1965, Los Angeles had produced the Byrds, the first real challenge to the British, but, as we have seen, it was San Francisco that was the seedbed of national psychedelia. It wasn't very long before music-conscious cities like Detroit, Chicago, and Austin began to spawn their own rock cultures.

Detroit especially understood the possibilities of the new music. Indeed, it exported a host of key personages to San Francisco, including artist Stanley Mouse and guitarist James Gurley, soon to be a Big Brother and the Holding Company mainstay. As early as 1966, a Detroit subcommunity was emerging within the San Francisco hippie scene. However many Detroit natives made the journey west, an even greater number remained at home, becoming the nucleus of a vibrant American counter-culture community with a social and artistic signature all its own.

The most prominent social activist in Detroit was John Sinclair, who became widely recognized in the late 1960s for his protests against police repression and unjust court rulings affecting him and the various counterculture communal groups he helped build.

Most important to the fostering of psychedelic music in Detroit was the opening of the Grande Ballroom as a rock dance palace late in 1966. Gary Grimshaw became the city's most widely recognized psychedelic poster artist. Grimshaw drew most of his posters, while his colleague, Carl Lundgren, created collages. The contrasting techniques helped develop the Grande posters into perhaps the finest body of psychedelic concert art outside San Francisco.

Grimshaw, Lundgren, and their friends created a body of art that rivaled the best of San Francisco, whereas Denver, St. Louis, Baltimore, Washington, Pittsburgh, Philadelphia, New York, and Chicago produced no distinctive schools. In those cities, newspaper and radio ads largely supplanted poster production. Austin, Texas, however, proved as strong a base for rock art as Detroit, and in San Francisco there were distinct communities of friends

hailing from both cities. Poster art played a significant role in popularizing the new music in Austin.

Los Angeles also spawned a major psychedelic movement, most notably in the Kaleidoscope and the Pinnacle concerts. The Kaleidoscope was the most amazing building of them all, the Fillmore and Avalon in San Francisco and the Electric Circus in New York notwithstanding. Located near Sunset and Vine in the heart of Los Angeles, it was built in the 1930s by showman Earl Carroll, who named it after himself. It featured an eighty-foot revolving stage with an additional six-foot outer ring that could revolve in the opposite direction. There was a "rainfall" curtain and jets that spat fire, along with an elevating orchestra pit. All of it—especially the revolving stages—had been built to accommodate extravaganzas of naked women. Local laws prohibited stripper-style entertainment, which was narrowly defined as nude women in motion. So Carroll created a theater in which the women stood stock still while the stages moved.

The Earl Carroll Theater next became the Moulin Rouge, then the stage set for the "Hullabaloo" live-music TV shows, then the Aquarius Theater, and, along the way,

the site of many 1950s TV game shows, including "Queen for a Day."

The Kaleidoscope and the Pinnacle concerts (whose home was the Shrine Auditorium) easily rivaled what was going on in L.A. clubs like the Whisky and the Troubador. But while the shape of Kaleidoscope art was unique, its artistic content was often prosaic compared with the highly imaginative Pinnacle graphics by John Van Hamersveld. Grimshaw in Detroit and Van Hamersveld in Los Angeles were the only psychedelic poster artists outside of San Francisco who produced a body of art comparable to the best the Bay city had to offer.

Monterey Pop Festival
Fairgrounds, Monterey, California, 1967
Artist: Tom Wilkes

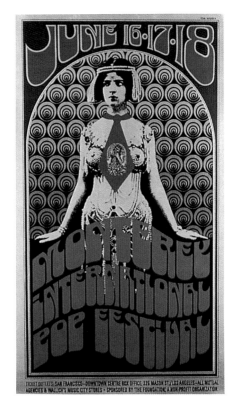

Cream; Grateful Dead
Memorial Auditorium, Sacramento, California, 1968
Artist: Art Print

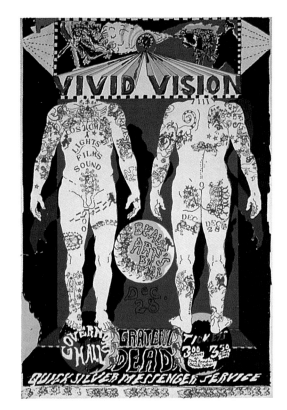

Beaux Arts Ball (version 2)
Governor's Hall, Sacramento, California, 1966

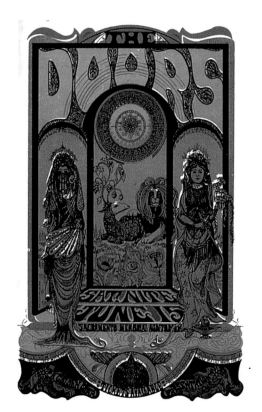

The Doors
Memorial Auditorium, Sacramento, California, 1968
Artist: Sam Sadofsky

Grateful Dead; Country Joe and the Fish
Selland Arena, Fresno, California, 1968
Artist: Cheryl Rankin

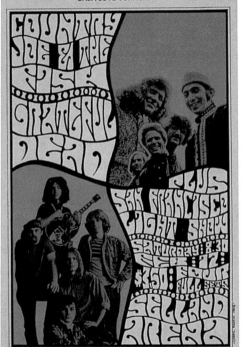

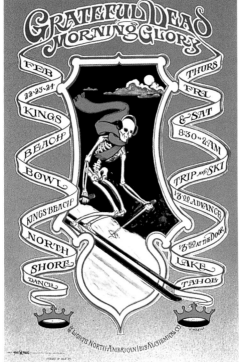

Grateful Dead: Morning Glory
Kings Beach Bowl, Lake Tahoe, California, 1968
Artist: Bob Fried

Jefferson Airplane
Earl Warren Showgrounds, Santa Barbara, California, c. 1968
Artist: R. Tolmach

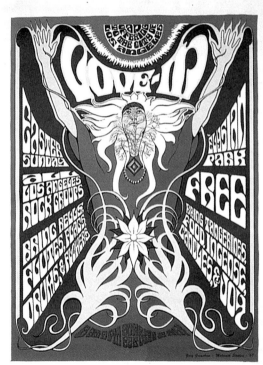

Love-In
Elysian Park, Los Angeles, 1967
Artist: Gary Grimshaw

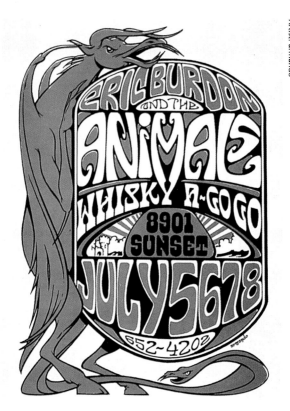

Eric Burdon and the Animals
Whisky a Go-Go, Los Angeles, c. 1968
Artist: armando

Orange Groove
Orange County Fairgrounds, Costa Mesa, California, 1967
Artist: Bob Fried

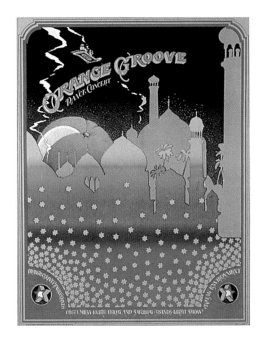

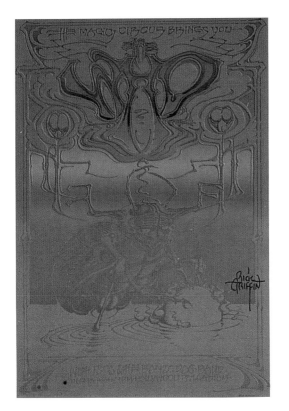

The Who; Poco
Palladium, Hollywood, 1969
Artist: Rick Griffin

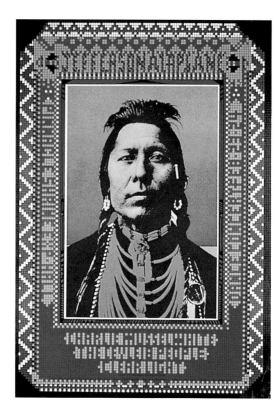

Jefferson Airplane; Charlie Musselwhite
Shrine Auditorium, Los Angeles, 1968
Artist: John Van Hamersveld

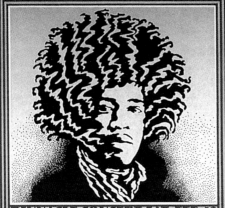

Jimi Hendrix: Electric Flag
Shrine Auditorium, Los Angeles, 1968
Artist: John Van Hamersveld

Buffalo Springfield; Grateful Dead ("Amazing Electric Wonders")
Shrine Exposition Hall, Los Angeles, 1967
Artist: John Van Hamersveld

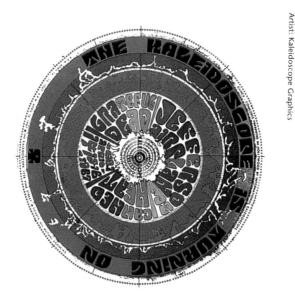

Jefferson Airplane; Grateful Dead
Kaleidoscope, Hollywood, 1967
Artist: Kaleidoscope Graphics

Jefferson Airplane; Buffalo Springfield
Kaleidoscope, Hollywood, 1968
Artist: Dahlgren

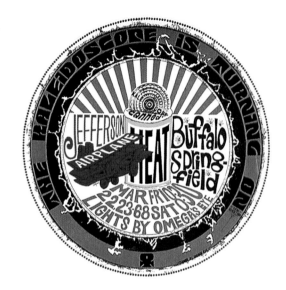

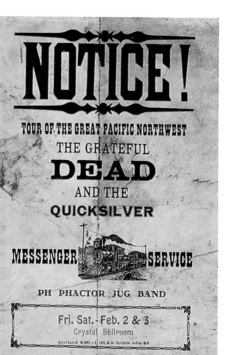

Grateful Dead: Great Pacific Northwest Tour (handbill)
Crystal Ballroom, Portland, Oregon, 1968
Artist: George Hunter

Jethro Tull; MC5
Eagles Auditorium, Seattle, 1969
Artist: John Moehring

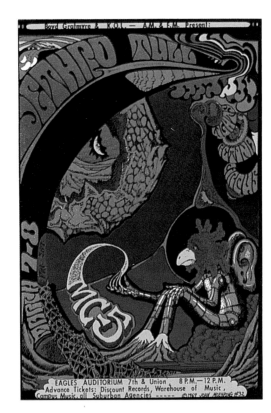

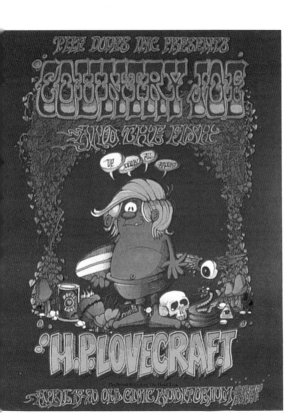

Country Joe and the Fish; H. P. Lovecraft
Old Civic Auditorium, Honolulu, c. 1969
Artist: Rick Griffin

Grateful Dead; It's a Beautiful Day (later reprint)
International Center, Honolulu, 1969

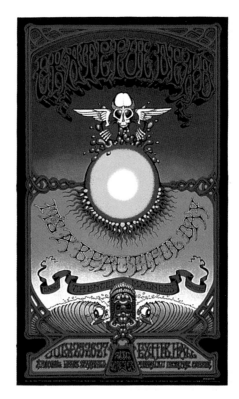

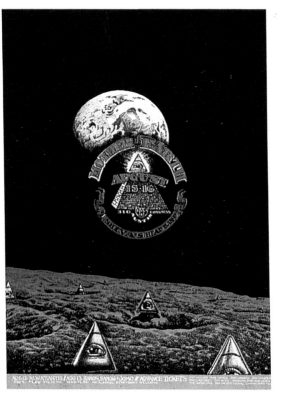

Mother Earth; Shiva's Head Band
Vulcan Gas Company, Austin, Texas, 1969
Artist: Jim Franklin

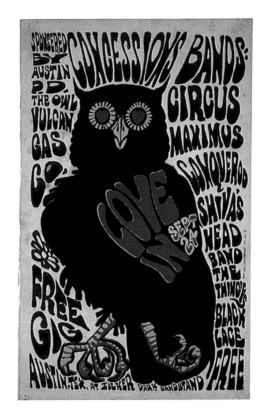

Austin Love In

Zilker Park Bandstand, Austin, Texas, c. 1968

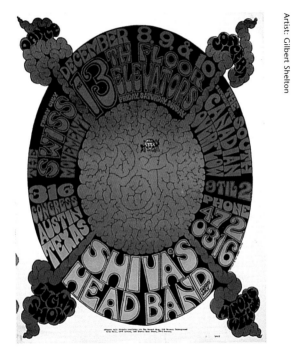

13th Floor Elevator: Shiva's Head Band
Vulcan Gas Company, Austin, Texas, 1967
Artist: Gilbert Shelton

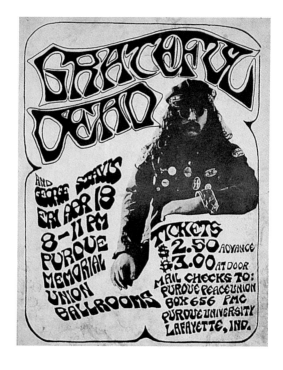

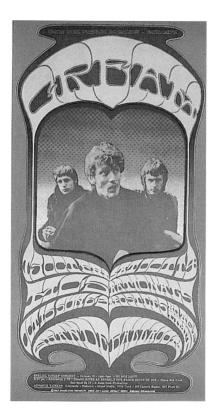

Cream; MC5
Grande Ballroom, Detroit, 1967
Artist: Gary Grimshaw

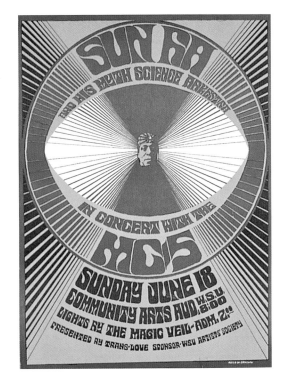

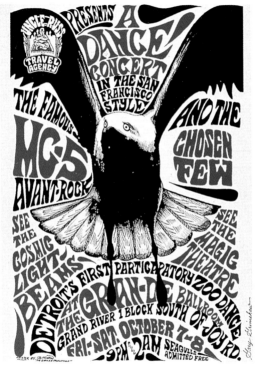

MC5; Chosen Few
Grande Ballroom, Detroit, 1967
Artist: Gary Grimshaw

First Annual Detroit Rock & Roll Revival
Michigan State Fairgrounds, Detroit, 1969
Artist: Gary Grimshaw

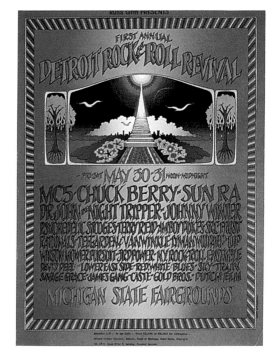

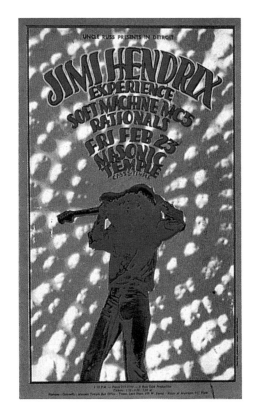

Jimi Hendrix Experience; Soft Machine
Masonic Temple, Detroit, 1968
Artist: Gary Grimshaw

Chambers Brothers; MC5
Grande Ballroom, Detroit, 1967
Artist: Gary Grimshaw

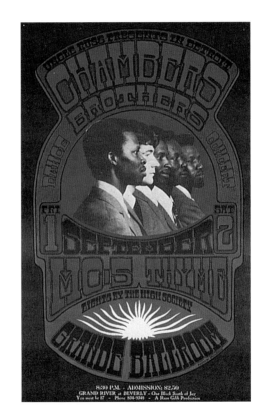

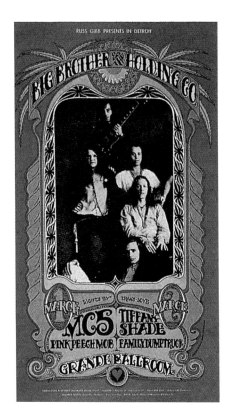

Big Brother and the Holding Company; MC5

Grande Ballroom, Detroit, 1968

Artist: Gary Grimshaw

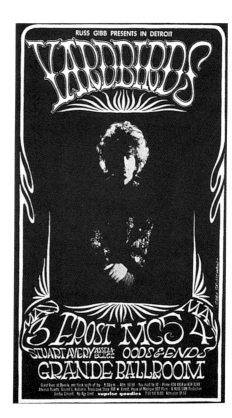

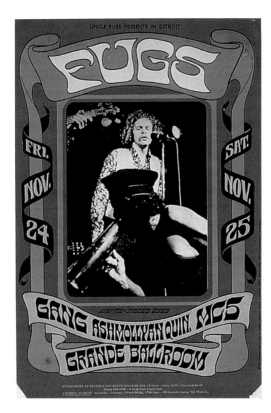

Fugs; MC5
Grande Ballroom, Detroit, 1967
Artist: Gary Grimshaw

James Cotton; MC5
Grande Ballroom, Detroit, 1967
Artist: Carl Lundgren. Photographer: V. Skreb

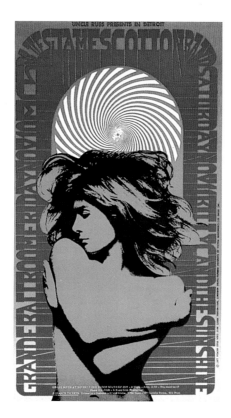

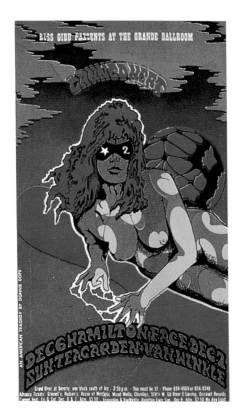

Canned Heat; Hamilton Face
Grande Ballroom, Detroit, 1968
Artist: Donny Dope

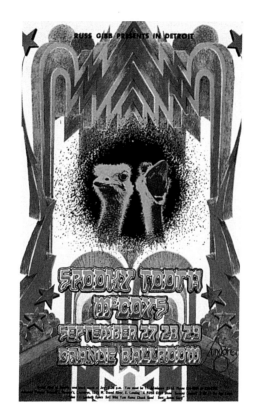

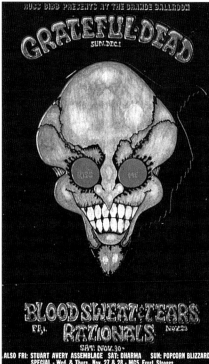

Quicksilver Messenger Service; Frost
Grande Ballroom, Detroit, 1968
Artist: Carl Lundgren

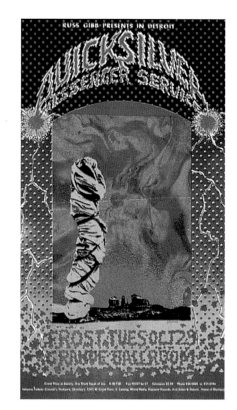

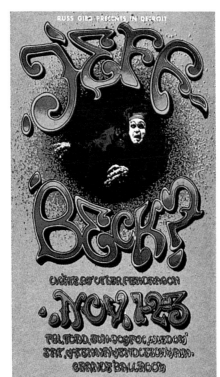

Jeff Beck: Toad
Grande Ballroom, Detroit, 1968
Artists: Carl Lundgren, Donny Dope

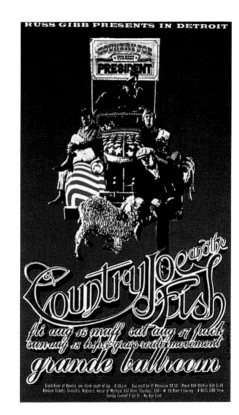

Country Joe and the Fish; Muff
Grande Ballroom, Detroit, 1968
Artist: Carl Lundgren

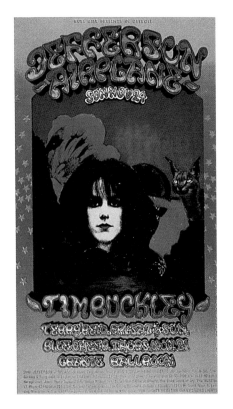

Jefferson Airplane; Tim Buckley
Grande Ballroom, Detroit, 1968
Artists: Carl Lundgren, Jerry Younkins, Donny Dope

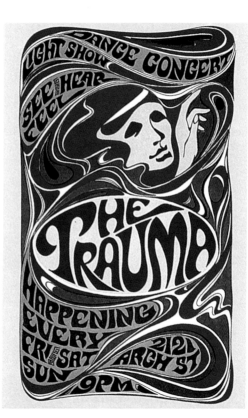

DARLING DAUGHTERS
SWEET MOTHERS DANCE
BLACKLIGHT DYNAMITE
ACROBATS ASTROLOGERS
JUGGLERS FREAKS CLOWNS
ESCAPE ARTISTS VIOLINISTS
GROK GRAPES GRASS
UPS DOWNS SIDEWAYS
COFFEE THINK TANK
AIR-CONDITIONED
IN MORE WAYS THAN ONE
THE ULTIMATE LEGAL
ENTERTAINMENT EXPERIENCE

THE ELECTRIC CIRCUS
OPENS JUNE 28, 1967
23 ST. MARKS PLACE, N.Y.C.,
EAST VILLAGE
THINK ABOUT IT.

Opening
Electric Circus, New York, 1967
Artist: Chermayeff and Geismar Associates

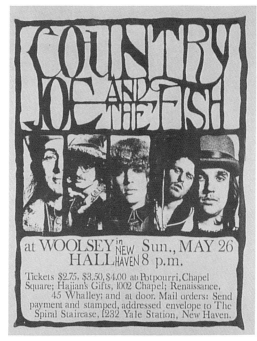

DECEMBER 29, 30, 31
THE GRATEFUL DEAD
THE BOSTON TEA PARTY 15 LANSDOWNE ST. 536·0915
Tickets·New Directions·Truc·George's Folly·Headquarters East

Grateful Dead: New Year's Eve
Boston Tea Party, Boston, 1969

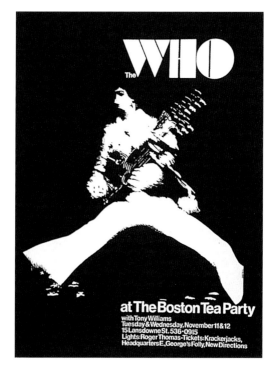

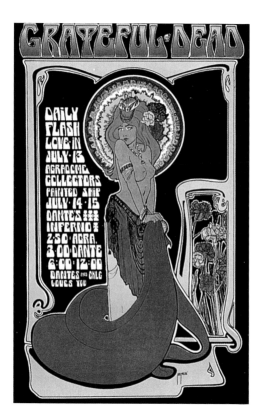

Grateful Dead; Daily Flash

Agradome/Dante's Inferno, Vancouver, 1967

Artist: Bob Masse

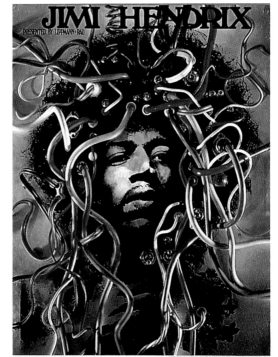

4.
THE MAINSTREAM

Maybe it's what's been happening in California, but now it's just a step ahead of what's about to happen here in Oklahoma.

BRIAN JAMES THOMPSON in conversation
Tulsa, Oklahoma, 1985

The 1970s were a time of fat cats and big bucks in rock music, and the successful exploitation of the music dramatically altered the course of rock 'n' roll. At first, the financial strength of 1970s rock was a joyous achievement; later, it was a reason for envy and suspicion; by the end of the decade, it had spawned such reactionary movements as punk and new wave.

A source of fulfillment and a target for derision, 1970s rock had very real power. In just a few years rock had risen from a counterculture movement to the dominant

popular art form. Woodstock was the turning point in the economic destiny of rock. Everything about the late 1960s culminated in Woodstock. A triumph of communal will, talent, and ideals, it marked the peak of what could be accomplished by harnessing rock's musical power to a great massing of youth. And it also ushered in a new era of exploitation engineered by what had become rock's own powerful establishment and a host of outside interests.

For all its idealism, Woodstock represented the first *full* realization of rock's commercial potential, its marketability. The poster art created for Woodstock is an example of the rapid evolution of this realization. Like much that surrounded Woodstock, the classic dove-and-guitar festival poster took on almost mythic proportions, becoming a sophisticated commercial emblem. Yet its mythic and commercial success were rooted in the same spontaneous, mostly unplanned evolution that characterized the genesis of the festival itself.

Woodstock—held the weekend of August 15–17, 1969—was produced after much apprehension and collective tension. But it just clicked—phenomenally. More than

400,000 fans made the trek to Max Yasgur's dairy farm outside Bethel, New York, jamming every freeway, county road, and dirt path. The journey became an epic pilgrimage.

The thought behind the initial poster design was innocent enough, since Woodstock, at its inception, was possessed of no more magic than any other rock festival of the late 1960s. But the event began to take on extraordinary stature just before it hit, and continued to increase in symbolic proportion years after it was held. The development of the second design for the Woodstock poster played into this process.

Woodstock was originally planned for a site outside the township of Wallkill in Sullivan County, New York. But just four weeks before the concert date, Wallkill's zoning board revoked the necessary licenses, and the promoters were forced to look for an entirely new location. The first Woodstock poster thus became obsolete before it was used. This poster was the work of David Byrd, known in New York City for his 1968 Fillmore East posters, which had caught the eye of Michael Lang, one of the four promoter partners in Woodstock Ventures. Byrd's poster

depicted a naked Aquarius—Woodstock was billed as the "Aquarian Exposition"—against a psychedelic background design.

When the Wallkill town fathers revoked permission for Woodstock, an eleventh-hour decision was made to relocate the festival. An intensive search for a new site led to the discovery of Max Yasgur's farm. New poster art was needed, and Woodstock Ventures hired artist Arnold Skolnick, who, unlike Byrd, was not known for any particular rock poster work. Nevertheless, his design—which first appeared in newspaper and then in poster form—has since become the classic graphic representation of Woodstock.

Three years after Woodstock, Bill Graham closed the Fillmore East (New York) and Fillmore West (San Francisco) concert halls. Graham understood that the new decade called for larger-sized concert production and tour management. His decision to close the Fillmore brought to an end a concert poster series that numbered almost three hundred works, and the task of creating a final Fillmore poster fell to David Singer. His effort is now regarded as a classic.

With the closing of the Fillmores in 1971, rock entered a mainstream period in which the music took the broadest avenues to popular acclaim. Accordingly, the poster art took on a slick, commercial professionalism. Indeed, mass media print ads supplanted much poster production. Nevertheless, several noteworthy exceptions continued to include poster commissions as part of promotional campaigns. As might be expected, the San Francisco bands were most reluctant to abandon concert posters. The Grateful Dead continued, throughout the new decade, to sustain an extremely personal relationship with its growing audience, still embodying a special energy well into the 1980s and still the cause of many concert posters. Another San Francisco band, Journey, also continued to see the value of powerful posters. During the 1970s, the rock poster also remained a useful promotional tool for smaller concert operations in less-traveled areas of the country. In such places, the rock poster continued to represent new opportunities for local artists.

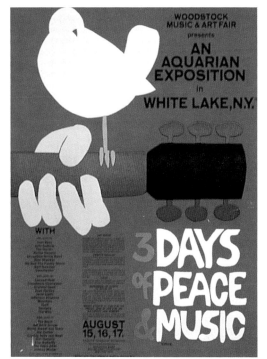

Final Woodstock Poster
Max Yasgur Farm, Bethel, New York, 1969
Artist: Arnold Skolnick

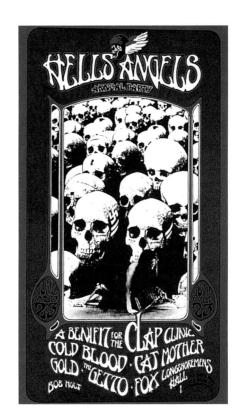

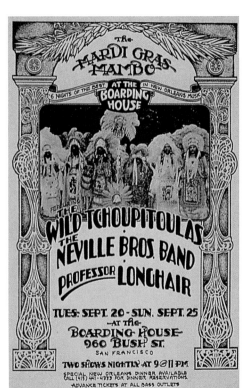

Mardi Gras Mambo
Boarding House, San Francisco, 1977
Artist: Randy Tuten

Sixth Annual San Francisco Blues Festival
Golden Gate Park Bandshell, San Francisco, 1978
Artist: Andrew Woodd

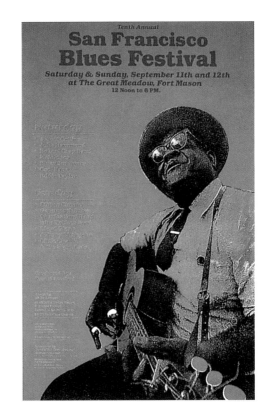

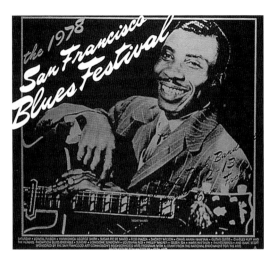

Tenth Annual San Francisco Blues Festival
Fort Mason, San Francisco, 1982
Artist: NAP Graphics

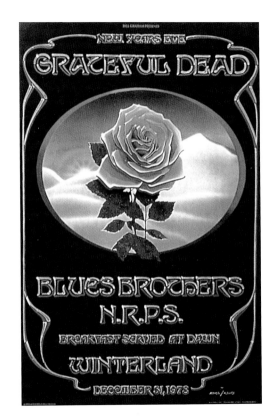

Grateful Dead: New Year's Eve Closing ("Blue Rose")
Winterland, San Francisco, 1978
Artists: Stanley Mouse , Alton Kelley

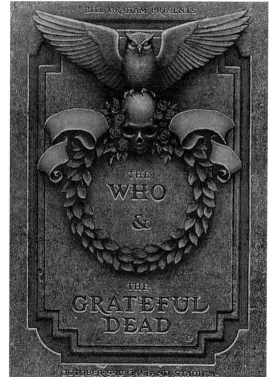

Grateful Dead; The Who
Stadium, Oakland, California, 1976
Artist: Philip Garris

Grateful Dead

Warfield Theater, San Francisco, 1980
Artists: Dennis Larkins, Peter Barsotti

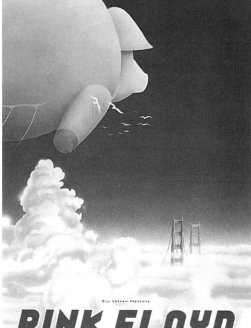

Pink Floyd
Coliseum, Oakland, California, 1977
Artists: Randy Tuten, William Bostedt

BILL GRAHAM PRESENTS

PINK FLOYD

OAKLAND COLISEUM
MAY 9 & 10, 1977

Tumbling Dice; Rolling Stones
Winterland, San Francisco, 1972
Artist: David Singer

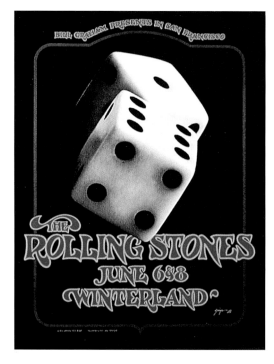

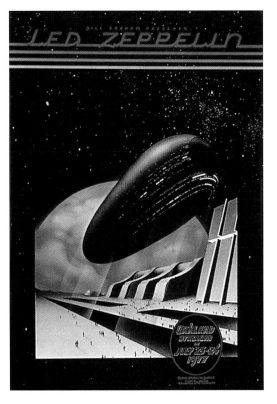

Led Zeppelin
Stadium, Oakland, California, 1977
Artists: Randy Tuten, William Bostedt

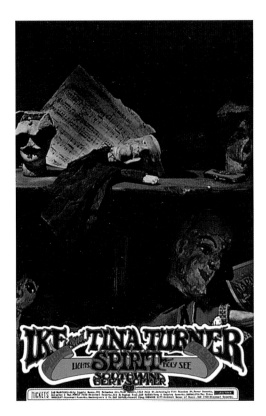

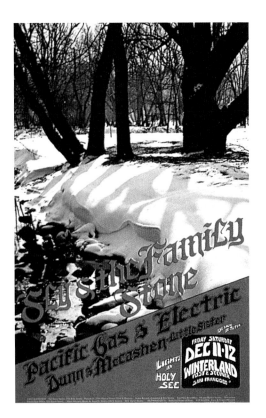

Sly and the Family Stone; Pacific Gas & Electric
Winterland, San Francisco, 1970
Artist: Randy Tuten

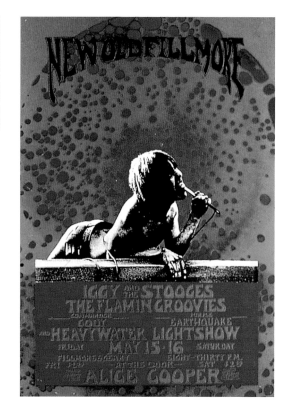

Iggy Pop; Flamin' Groovies
Fillmore Auditorium, San Francisco, 1970
Artists: Mark T. Behrens, Burke

Dinosaurs
Wolfgang's, San Francisco, 1983
Artists: Alton Kelley, Randy Tuten

Dinosaurs

Kabuki Theater, San Francisco, 1984

Artist: Alton Kelley

A Night to Remember—Boz Scaggs
Paramount Theatre, Oakland, California, 1975
Artist: Mikel Covey

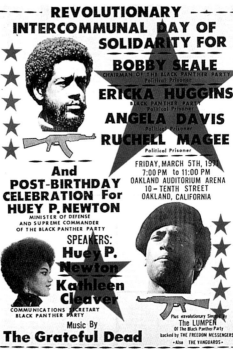

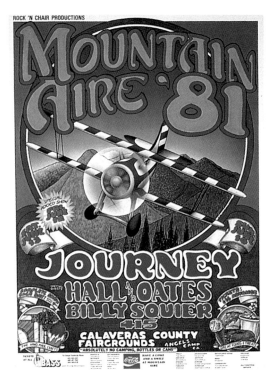

Mountain Aire '81
Calaveras County Fairgrounds, Angels Camp, California, 1981
Artist: Roger Labon Jackson

Mountain Aire '83
Calaveras County Fairgrounds, Angels Camp, California, 1983
Artist: Roger Labon Jackson

ROCK 'N CHAIR PRODUCTIONS

10TH ANNUAL

Mountain Aire '83

TOM PETTY and the
HEARTBREAKERS
MEN AT WORK
STRAY CATS
PLUS MORE TO BE ADDED!

SAT. JUNE 4

SUN. JUNE 5

CALAVERAS COUNTY FAIRGROUNDS • ANGELS CAMP • CA

"ABSOLUTELY NO CAMPING, BOTTLES OR CANS"

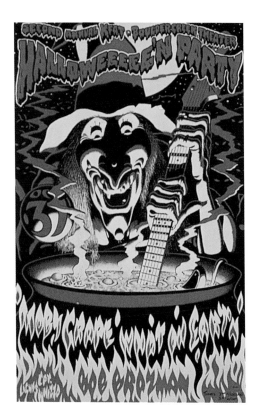

Second KFAT Halloween Party
Theater, Boulder Creek, California, 1977
Artist: Jim Phillips

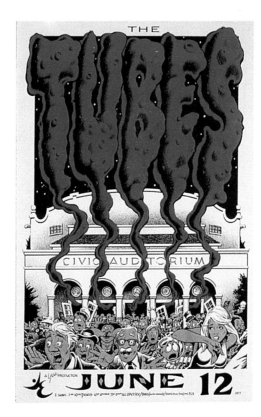

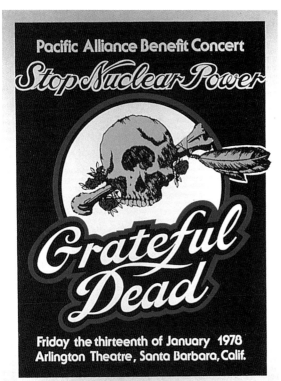

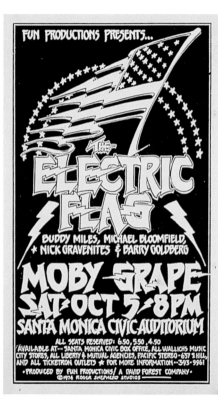

Electric Flag; Moby Grape
Civic Auditorium, Santa Monica, California, 1974
Artist: Roger Shepherd

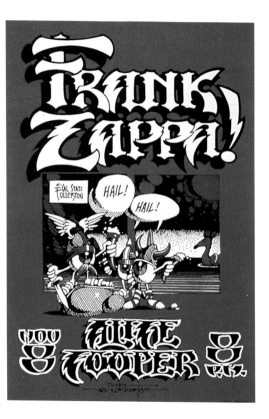

Frank Zappa; Alice Cooper
California State College, Fullerton, c. 1972
Artist: Rick Griffin

Bruce Springsteen: A Night for the Vietnam Veteran
Sports Arena, Los Angeles, 1981

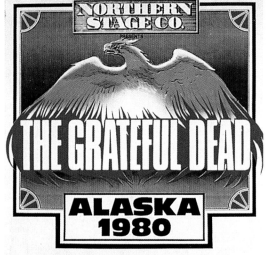

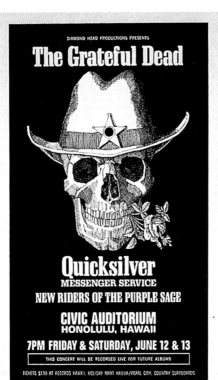

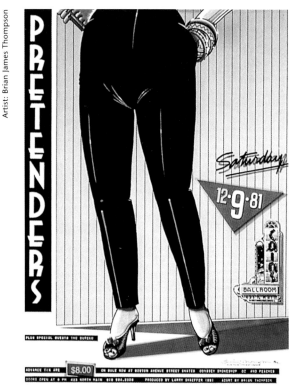

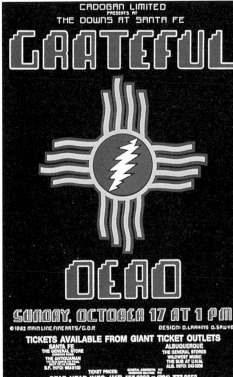

Grateful Dead
Downs, Santa Fe, New Mexico, 1982
Artists: Dennis Larkins, D. Sawyer

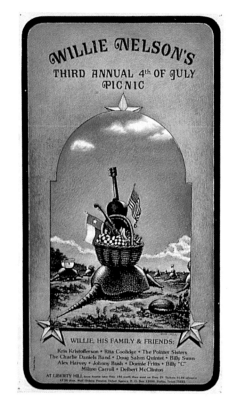

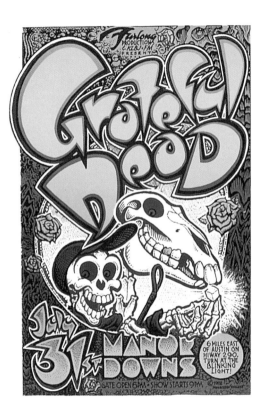

Grateful Dead
Manor Downs, Texas, 1982
Artist: Michael Priest

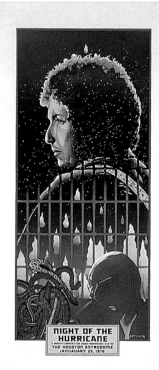

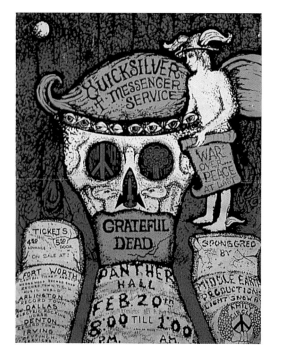

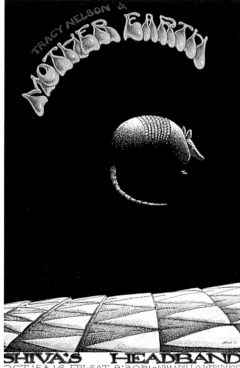

Ramon-Ramon and the 4 Daddyos; T. Thelonious Troll
Armadillo World Headquarters, Austin, Texas, 1970
Artist: J. Shelton

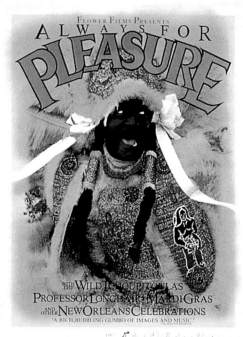

Film: *Always for Pleasure*, 1980
Artists: Michael Smith, Mischa Phillippott

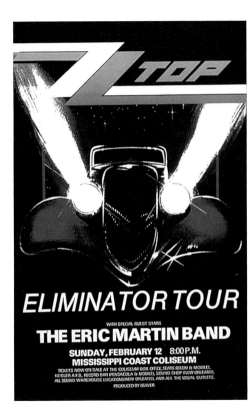

FOCUS
mark almond
J. GEILS BAND

FRIDAY **9** MARCH
BOWEN FIELD HOUSE

Eastern Michigan University, Ypsilanti

TICKETS: reserved seats 2.50·3.50·4.50 OUTLETS: McKenny Union, Huckleberry
Party Store, Ann Arbor Music Mart, and all Hudson's · 8pm

J. Geils Band; Focus
Eastern Michigan University, Ypsilanti, Michigan, 1973
Artist: Gary Grimshaw

Iggy Pop; Reruns
Bookie's Club, Detroit, 1980
Artist: Gary Grimshaw

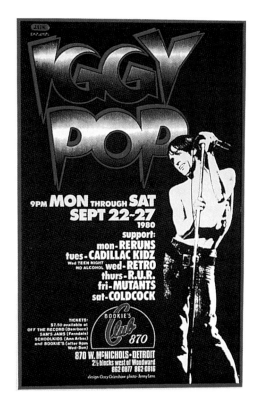

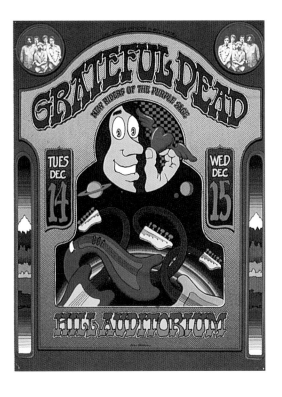

Grateful Dead: New Riders of the Purple Sage
University of Michigan, Ann Arbor, 1971
Artist: Gary Grimshaw

Buddy Guy; Fred McDowell
The Park, North Baltimore, Ohio, 1971
Artist: Gary Grimshaw

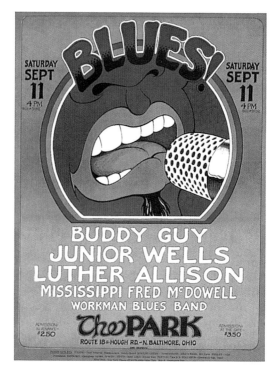

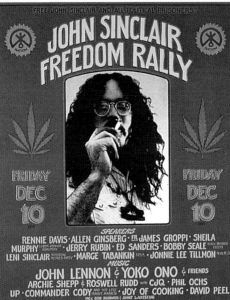

John Sinclair Freedom Rally
University of Michigan, Ann Arbor, 1971
Artist: Gary Grimshaw

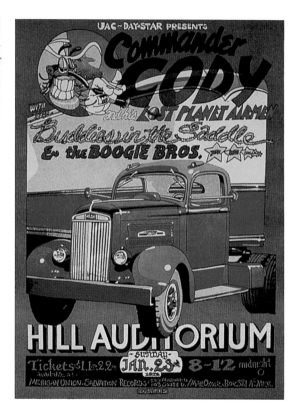

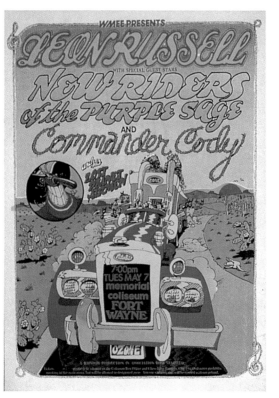

Leon Russell; Commander Cody
Memorial Coliseum, Fort Wayne, Indiana, 1974
Artist: Chris Frayne/Ozone

Grateful Dead; It's a Beautiful Day
Aragon Ballroom, Chicago, 1970
Artist: Daniel Clyne

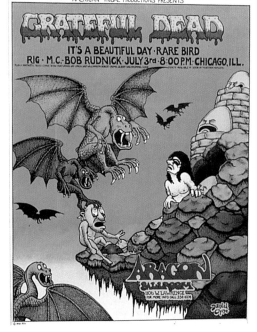

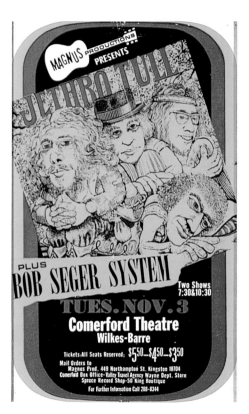

Jethro Tull; Bob Seger System
Comerford Theater, Wilkes-Barre, Pennsylvania, 1970

Iron Maiden; Quiet Riot
Madison Square Garden, New York, 1983

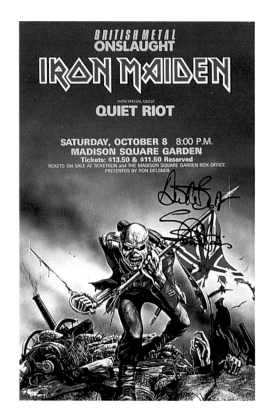

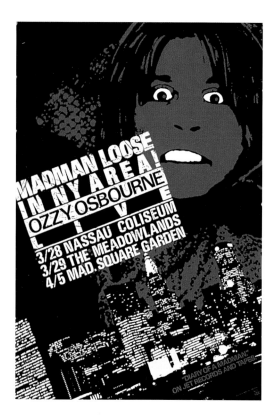

Ozzy Osbourne
Multiple venues, New York and New Jersey, 1982

Grateful Dead: A Swell Dance Concert
Nassau Coliseum, Uniondale, New York, 1973
Artist: David Byrd

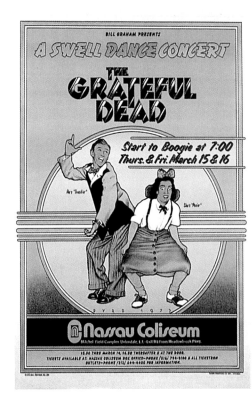

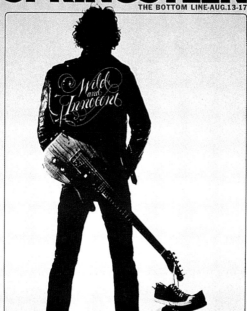

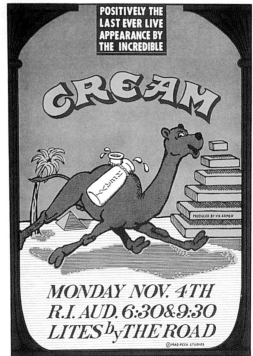

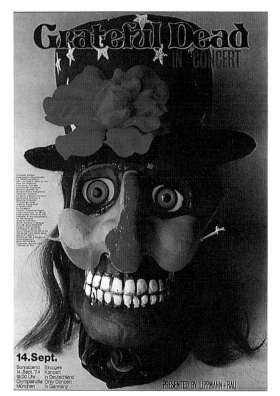

Grateful Dead ("Painted Skull")
Olympiahalle, Munich, West Germany, 1974
Artist: Gunther Kieser

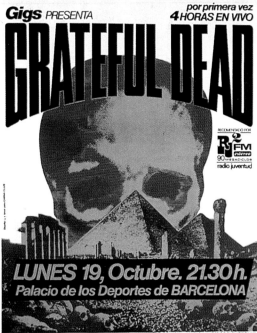

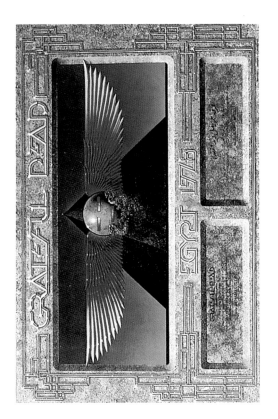

Grateful Dead in Egypt
Great Pyramid, Giza, Egypt, 1978
Artist: Alton Kelley

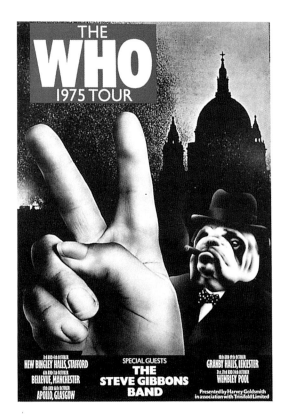

The Who "1975 Tour"
Multiple venues, United Kingdom, 1975
Artist: John Pasche

The Who
Olympiahalle, Munich, 1976
Artist: Gunther Kieser

Bob Dylan; Santana; Joan Baez
Parc des Sceaux, Paris, 1984

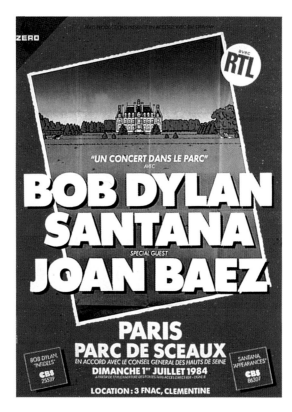

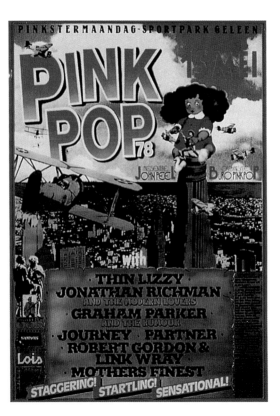

Pink Pop Festival
Sportpark Geleen, Netherlands, 1978

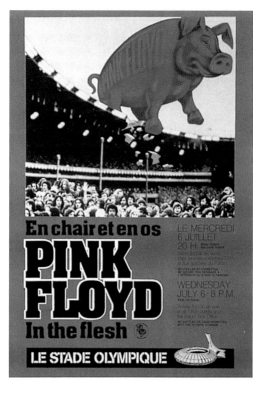

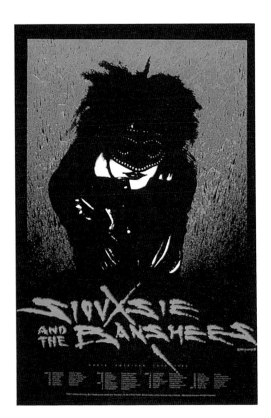

Siouxsie and the Banshees
Multiple venues, 1986
Artist: Stanley Mouse

The Cure "European Tour"
Multiple venues, 1984

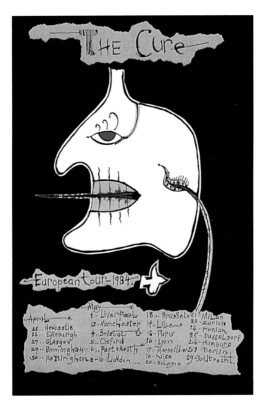

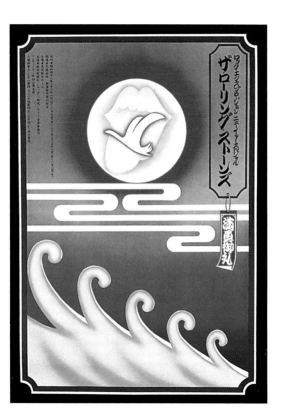

Rolling Stones—Rock Explosion New Year Special
Budokan Large Hall, Tokyo, 1973

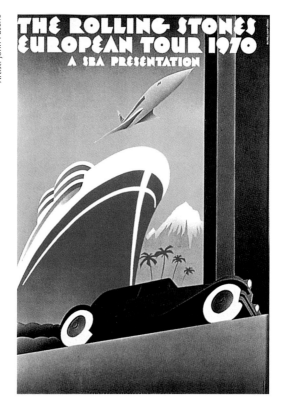

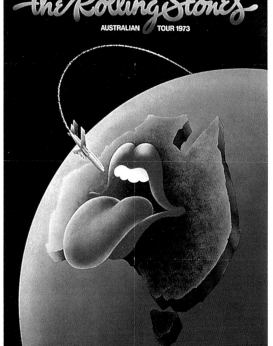

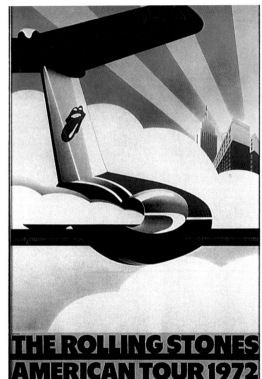

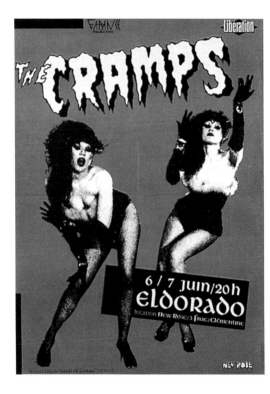

The Cramps
Eldorado, Paris, 1984

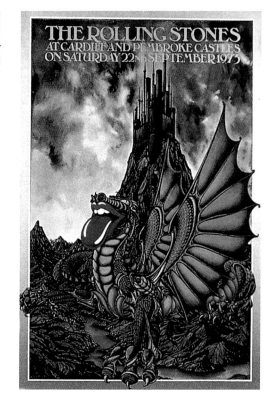

Rolling Stones
Cardiff Castle, Wales, 1973
Artist: J. Purness

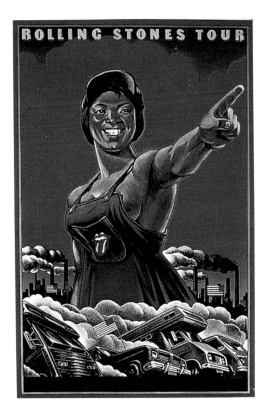

Rolling Stones Tour
1978
Artist: Raindrop Productions

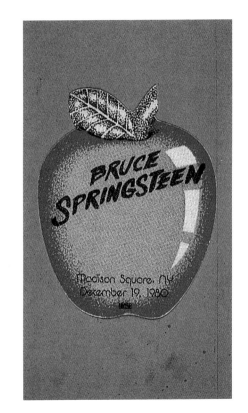

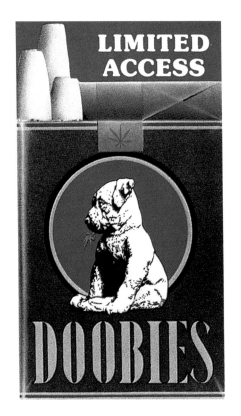

Laminated limited-access pass: Doobie Brothers
Tour, 1979
Artist: Stanley Mouse

5.
THE NEW MUSIC

I've never gotten the same thrill out of having one of my cartoons printed in a magazine as much as seeing one of my old fliers—something I did for a punk gig the week before—laying in the gutter. Seeing it all mashed and dirty thrilled *me, because that was how I was living, too. It looked exactly like my life.*

SHAWN KERRI in conversation, 1986

Punk and new wave poster art evolved during the 1970s and 1980s. The rise of punk and new wave was as much a challenge to the rock music establishment as were the psychedelic developments of the late 1960s. Mainstream rock of the 1970s had become big business, slick, professional, and removed from its audience. It had become *safe.* Punk and new wave offered anything but safety and predictability. This was music—as well as fashion and graphic art—for people who flaunted their outrageous-

ness. Punk and new wave seemed the first indication of some new, unsuspected *now*. Brusque, angular, sarcastic, trashy, and disgusting, it was rock in its most innocent form. It was also a whole lot of fun.

Punk and new wave—originally interchangeable descriptions of the artistically deviant—first surfaced in "garage band" activity beginning in the late 1960s, contemporary with the later phases of the more successful psychedelic movement. Crude bands like San Jose's Count Five (which had the underground hit "Psychotic Reaction") were rough foils to the virtuosity that finally peaked in the mid-1970s. Garage-band rock was the fulfillment of the common man's rock consciousness, the desire to kick out the jams—however limited one's talent. Punk persisted in this attitude, while new wave came to represent artier aspirations.

As the 1960s came to a close, a number of art-rock bands, led by Lou Reed's Velvet Underground and the New York Dolls, appeared in various urban centers; they embodied elements of punk as well as new wave. These trendy new explorations accelerated with the emergence of British rocker David Bowie and led to producer Malcolm

McLaren's founding the Sex Pistols. A small audience developed for the first art-rock bands—never a national upsurge of interest or commitment until, in the early 1970s, a real American provocateur appeared and took up the sort of mesmerizing, disquieting presence that Jim Morrison of the Doors had earlier personified. This was Iggy Pop, out of Detroit, backed by the appropriately named Stooges. Iggy, the most out-of-control presence that had been seen on a stage for a decade, had no regard for conventional limits. The instant debauchery he could whip up suggested new possibilities for uncontrolled excess in rock 'n' roll. Everything Iggy stood for was rude, crude, and *alive.*

By the mid-1970s, bands like Talking Heads, Blondie, Television, and the Heartbreakers appeared on the scene, often performing at CBGB, a club in Manhattan's seedy Bowery. Then came the Ramones, from the upper-middle-class enclave of Forest Hills, Queens. Clad in leather and pushing rock to breakneck speeds, they touched off the punk revolution, which now began to become distinct from new wave. According to Legs McNeil, writing in *Spin* magazine, it was the Ramones who inspired the punk

groups destined to be identified as the genre's prototypes: the Clash, the Pretenders, the Damned, and the Sex Pistols.

Poster art accompanied every phase of punk and new wave development. It was produced in greater and greater profusion—and with an evolving degree of sophistication—as the music gathered momentum. If punk and new wave music sounded very different from the mainstream, its graphic art looked and felt different as well. The louder the posters spoke, the weirder they looked, the funnier the inside jokes they conveyed, the more they partook of the new sensibility. But for all the noise it made—and making noise was one of its basic intentions—punk and new wave art had the seductive appeal of the mischief that formed an unspoken bond among punks and new wavers.

If punk and new wave art owed something to anything, it was to the "boxing style" art of the 1950s and early 1960s. The new posters shared the bold and relentless nature of the original black music posters. Certainly, there is a tremendous difference in graphic style between the old and the new work, just as there is between black

music of the 1950s and early 1960s and punk and new wave rock. Yet both poster styles tend toward the loud and uncomplicated. They are designed to be noticed and intended to have a repetitive effect. In their overkill manner, they promise music that is appealing as well as low down and dirty.

Like the black music poster, the punk and new wave poster was shaped by the street. From the moment it is posted, this art becomes part of the neighborhood, its message gaining strength from repetition of sheer numbers—though the effective life of a single poster is perhaps only a week.

While history deemed New York and London the focal points of the new music, it was San Francisco that produced the greatest volume of punk and new wave poster art.

The San Francisco band that most exemplified new wave—in contrast to punk's harder core—was SVT. Its poster graphics and newspaper advertisements were created by the band's resident artist, Richard Stutting, who also designed more mainstream work for bands like Santana. Stutting's art bears a truly individual stamp that

helped define the new wave school of art. Most of his work was done under the name of Artbreakers.

The Bay area produced many other bands whose graphic art felt just like their music. One such as the idiosyncratically spelled Psycotic Pineapple, based in Berkeley and regarded locally more as a garage band than as new wave or even punk. But it was a band with both new wave and punk tendencies, and it produced some of the wittiest art seen on either coast.

Seattle, with Austin, Texas, was one of the few cities beyond San Francisco, New York, and Los Angeles that developed a significant punk and new wave presence. While many of the Seattle posters were done by band members, artists like Helena Rogers (Student Nurse), Gary Minkler (Red Dress), and Erich Werner (the Blackouts) created brilliant works, which, despite constant police harassment, were posted throughout the city.

The punk rebellion in Austin, as in San Francisco and Seattle, was finally suffused with the kind of good feelings that had characterized much of the psychedelic era. Los Angeles was a different story, its punk the most hard core of all, embodying few artistic pretensions—aside from

those of the nationally known group X. According to Club 88 owner Wayne Mayotte, interviewed in the film *The Decline of Western Civilization,* hard-core L.A. punk was characterized by speed, "the fuzz"—what's cranked into it, high volume, monotone vocals, and protest lyrics. But even the anarchic Los Angeles scene produced provocative posters and highly imaginative artists, among them Gary Panter (who handled work for the Screamers) and Shawn Kerri, a cartoonist whose work appeared (under a nom de plume) in *Hustler* and who enjoyed a close relationship with L.A.'s notorious Circle Jerks.

Raucous, wild, and frightening, punk music and graphics were also about intimacy and the sharing of secrets. The facilitation of communication among punks seemed to be as much the intent of street art as was the promotion of particular gigs. Like the rock 'n' roll music and imagery of the 1950s, the "new music" of the 1970s and 1980s provided, through graphics as well as sound, a special community of acceptance, at once exclusive and all-welcoming.

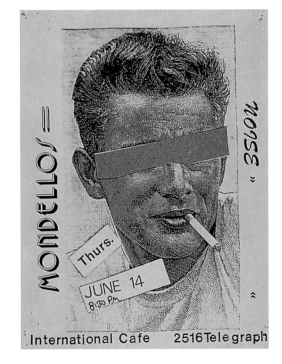

Pretenders; Iggy Pop
Henry J. Kaiser Auditorium, Oakland, California, 1987
Artist: Arlene Owseichik

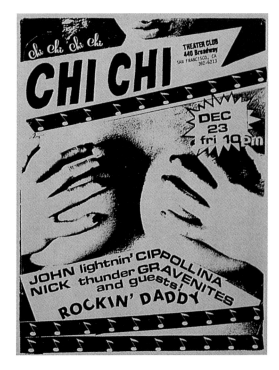

John Cipollina and Nick Gravenites; Rockin' Daddy
Chi Chi Club, San Francisco, 1983

Eye Protection; Jim Carroll
Back D.O.R./Old Waldorf, San Francisco, 1981
Artist: Joseph Prieboy

Mutants; Aliens
Back D.O.R., San Francisco, 1980
Artist: Brenda Shahan

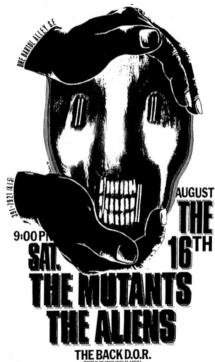

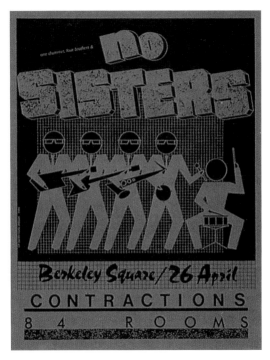

one chanteuse, four brothers &

no
SISTERS

Berkeley Square / 26 April

CONTRACTIONS
8 4 ROOMS

No Sisters: Contractions
Berkeley Square, Berkeley, California, 1980
Artist: Tim Barrett

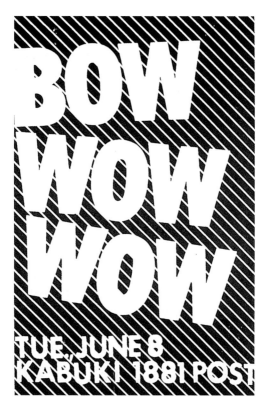

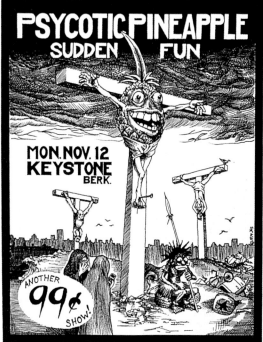

Psycotic Pineapple: Sudden Fun
Keystone Berkeley, Berkeley, California, 1979
Artist: John Seabury

SVT; Jim Carroll
Old Waldorf, San Francisco, 1979
Artist: Richard Stutting/Artbreakers. Photographer: Steve Gruver

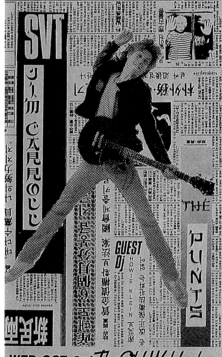

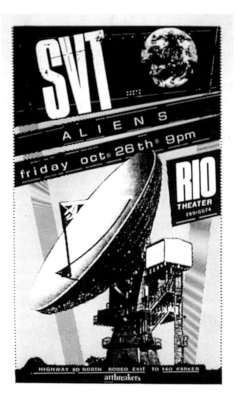

SVT: Aliens
Rio Theater, Rodeo, California, 1979
Artist: Richard Stutting/Artbreakers

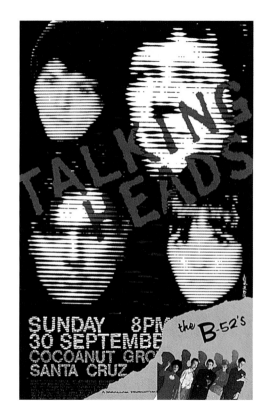

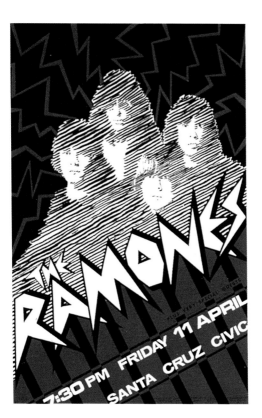

Ramones
Civic Auditorium, Santa Cruz, California, 1980
Artist: Su. Suttle

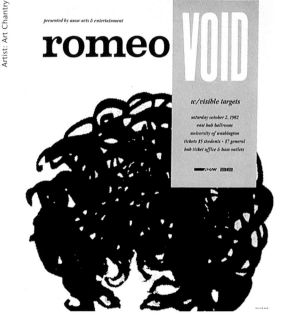

presented by asuw arts & entertainment

romeo

VOID

w/visible targets

saturday october 2, 1982
east hub ballroom
university of washington
tickets $5 students · $7 general
hub ticket office & bass outlets

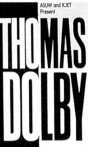

ASUW and KJET
Present

THOMAS DOLBY

and
MODERN ENGLISH

May 26, 8PM
HUB Ballroom
UW Campus

Tickets: $11.00
UW Students: $8.50

Available at HUB
Ticket Office,
South Campus
Center ticket
office, and all
Ticketmaster
outlets.

ASUW

Absolutely NO Cameras
or Tape Recorders
Allowed!

Don't miss video party at
Skisachies. Listen to
KJET for Details.

Thomas Dolby: Modern English
University of Washington, Seattle, 1984
Artist: Art Chantry

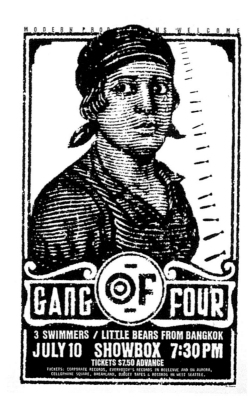

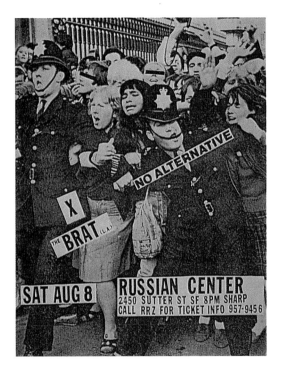

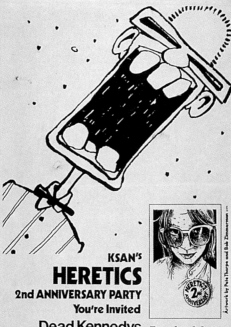

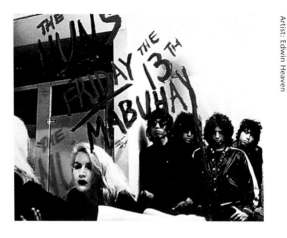

Nuns
Mabuhay Gardens, San Francisco, 1977
Artist: Edwin Heaven

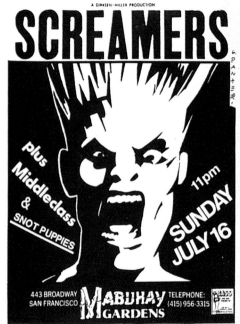

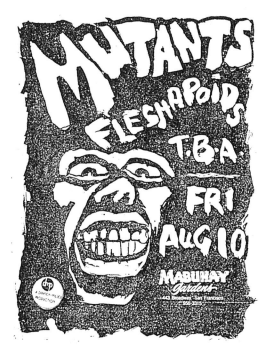

Mutants: Fleshapoids
Mabuhay Gardens, San Francisco, 1979

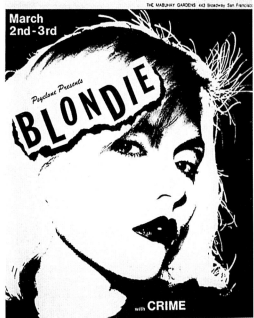

Suicide Hotline Benefit
Mabuhay Gardens, San Francisco, 1981

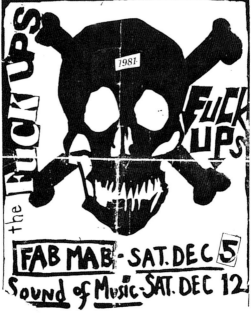

Fuck Ups
Mabuhay Gardens, Sound of Music, San Francisco, 1981
Artist: Bob Noxious

WED.
JULY 21

SOUND of MUSIC

Geeks
Sound of Music, San Francisco, 1982

Barry Beam; Los Microwaves
Tool & Die, San Francisco, 1981
Artists: Peter Belsito and Lisa Fredenthal

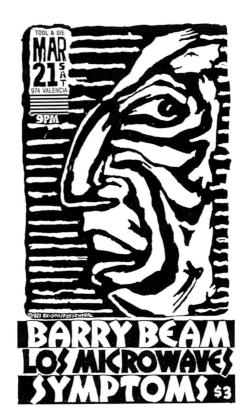

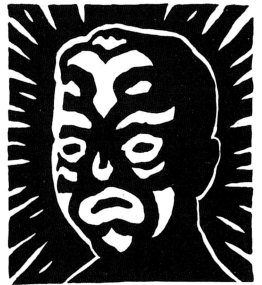

Minimal Man; Pink Section
Back D.O.R., San Francisco, 1980
Artist: Patrick Miller

MINIMALMAN
PINK SECTION
BOB
soul rebels
sunday 13 9:00 back dor!

Tuxedomoon: Minimal Man
Victoria Theater, San Francisco, 1981
Artist: Patrick Miller

TUXEDOMOON
MINIMAL MAN

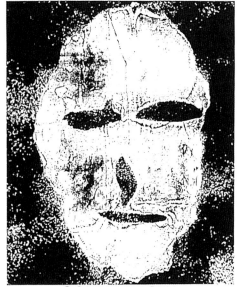

SOUND OF SEX

FEB 19 THU 9:00PM VICTORIA THEATER 2961 16TH ST NR MISSON
RRZ 864-1639

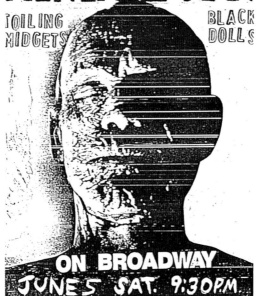

Minimal Man: Toiling Midgets
On Broadway, San Francisco, 1982
Artist: Patrick Miller

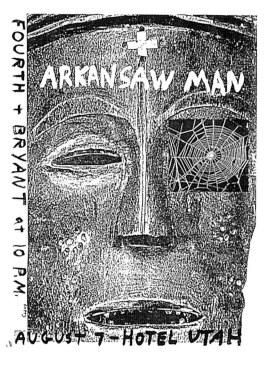

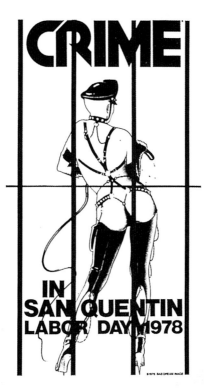

Crime
San Quentin Prison, Marin County, California, 1978
Artist: James Stark

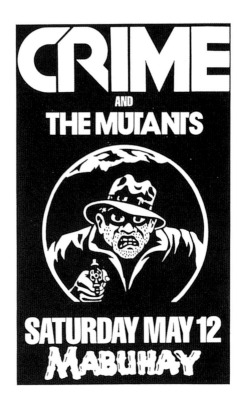

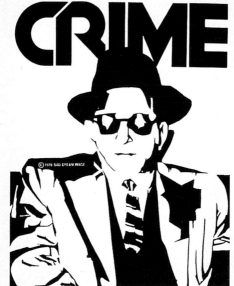

CRIME

SAN FRANCISCO ART FESTIVAL
CIVIC CENTER SUNDAY OCTOBER 1

Crime
Civic Center, San Francisco, 1978
Artist: James Stark

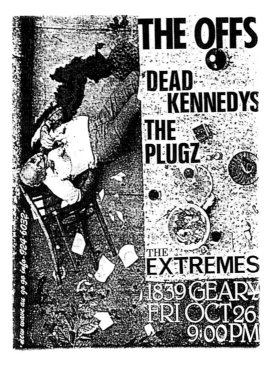

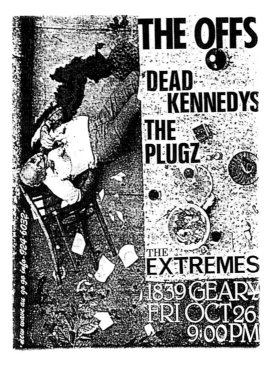

Offs; Dead Kennedys
1839 Geary, San Francisco, 1979

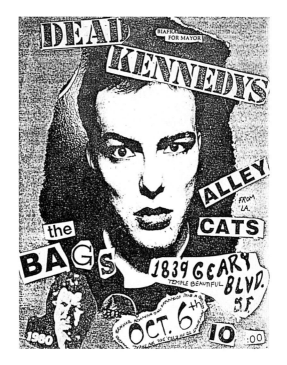

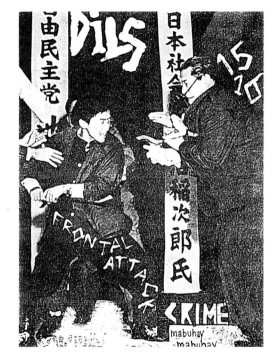

Dils: Crime
Mabuhay Gardens, San Francisco, 1978
Artist: Jean Caffeine

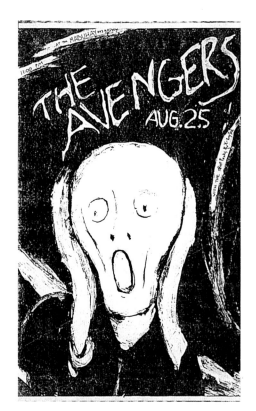

X: Gears
Florentine Gardens, Los Angeles, 1981
Artist: Richard Duarte

FEAR

GEARS
ANGRYSAMOANS
BLACKIES DEC.27

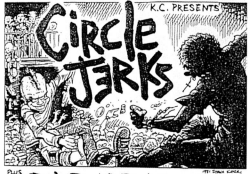

Circle Jerks; Bad Brains
California State University, Northridge, 1981
Artist: Shawn Kerri

K.C. PRESENTS

CIRCLE JERKS

PLUS

1981 SHAWN KERRI

BAD BRAINS
CIRCLE ONE
PUBLIC NUISANCE

C.S.U.N., NORTH CAMPUS
(FORMERLY DEVONSHIRE DOWNER)
MARCH 27, 8:00 (AT NITE) 1800 DEVONSHIRE, NORTH RIDGE
$7.50 IN ADVANCE, TICKS AVAILABLE AT TICKETRON. $8.00 AT THE DOOR!
FO' INFO' (213) 901-7265

Black Flag; Fear

Stardust Ballroom, Los Angeles, 1981

Artist: Raymond Pettibone

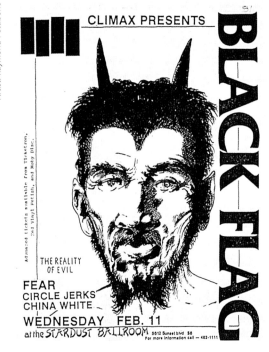

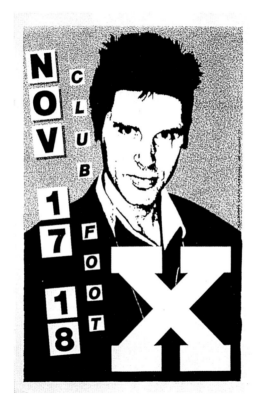

X
Club Foot, Austin, Texas, 1982
Artists: Paul Sabal, Andy Blackwood, Carbonee

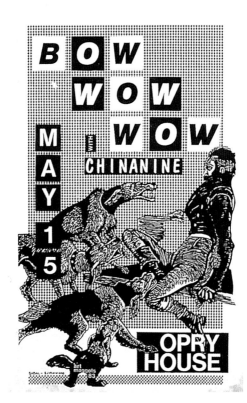

Units; Blackouts
Baby O's, Seattle, c. 1980
Artist: Erich Warner

Appendix:
THE POSTER SHOPS

Excellent sources for rock posters include:

Paul Getchell
PO Box 150036
San Rafael, CA 94915

The Poster Addict
3249 Potomac Court
Ann Arbor, MI 48108

D. King Gallery
2284 Fulton Street
Berkeley, CA 94704

SF Rock Posters
1851 Powell Street
San Francisco, CA 94133

Eric King
PO Box 9278
Berkeley, CA 94709

Uforick Posters
450 Amanda Lane
Crescent City, CA 95531

L'Imagerie
10555 Victory Boulevard
North Hollywood, CA 91606

Village Music
31 Sunnyside Avenue, No. 5
Mill Valley, CA 94941

Jim Phillips
PO Box 2512
Santa Cruz, CA 95063

SELECTED **TINY FOLIOS**™ FROM ABBEVILLE PRESS

American Impressionism 978-0-7892-0612-1

Antonio Gaudi 978-0-7892-0690-9

Audubon's Birds of America: The Audubon Society
 Baby Elephant Folio 978-0-7892-0814-9

Ansel Adams 978-0-7892-0775-3

The Great Book of Currier & Ives' America 978-1-55859-229-6

Illuminated Manuscripts: Treasures of the Pierpont
 Morgan Library 978-0-7892-0216-1

Japanese Prints 978-0-7892-0613-8

Norman Rockwell: 332 Magazine Covers 978-0-7892-0409-7

Treasures of the Brooklyn Museum 978-0-7892-1278-8

Treasures of the Museum of Fine Arts, Boston
 978-0-7892-1233-73

Treasures of the National Museum of the American Indian
 978-0-7892-0841-5

Treasures of the New-York Historical Society
 978-0-7892-1280-1

Women Artists: National Museum of Women in the Arts
 978-0-7892-1053-1

Frank Lloyd Wright: America's Master Architect
 978-0-7892-0227-7